SHANGHAI GIRL
GETS ALL DRESSED UP

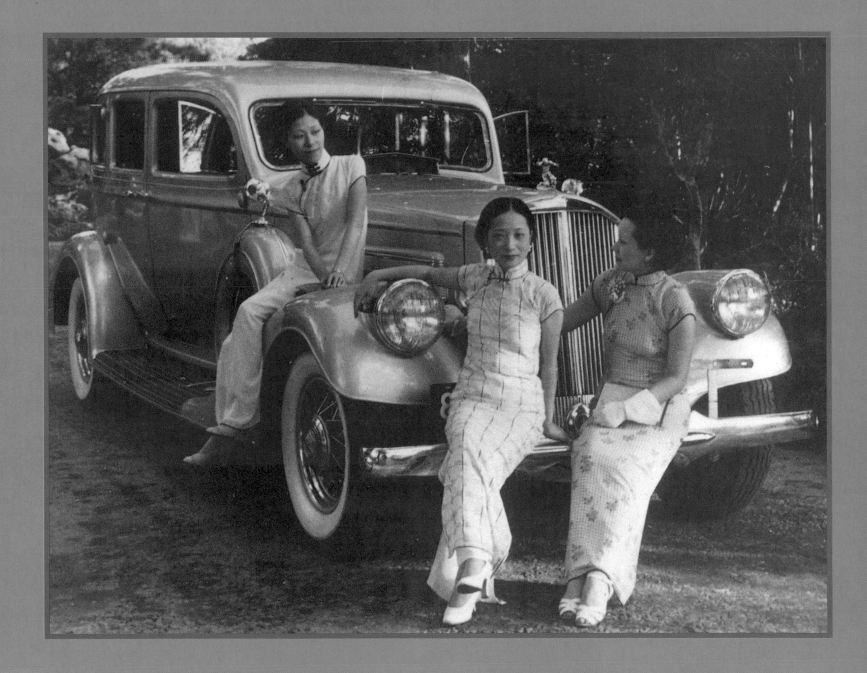

SHANGHAI GIRL
GETS ALL DRESSED UP

Beverley Jackson

TEN SPEED PRESS
Berkeley | Toronto

This book is dedicated to Tracey, Taylor, and Lucy

TEN SPEED PRESS
PO Box 7123
Berkeley CA 94707
www.tenspeed.com

Distributed in Australia by Simon & Schuster Australia, in Canada by Ten Speed Press Canada, in New Zealand by Southern Publishers Group, in South Africa by Real Books, and in the United Kingdom and Europe by Airlift Book Company.

Cover and text design by Brad Greene / Greene Design

The Library of Congress Cataloging-in-Publication data on file with the publisher.

ISBN 10: 1-58008-367-6

ISBN 13: 978-1-58008-367-6

Printed in China

First printing, 2005

1 2 3 4 5 6 7 8 9 10 – 09 08 07 06 05

With special thanks to Dr. Raymond Lum without whom I could not write my books, and Steve Boyiajian; Douglas Chong; Janson Chow; Clarissa Dong; John Fong; Patricia, Countess Jellicoe; Tess Johnston; Emily Kai; Joanne and Bob Kendall; Peter Lee; Roberto Liera; Edith Liu; Max McCullough; Ian Morrison; Judy and Glenn Roberts; Hania Tallmadge; Terence Tan; G. Gilbert Templeton; Sandor Vanocur; Yi Wei; Winifred Wood; Shirley Xu; Sherry and David Zhang; Barnsie, the late Lady Sassoon; and my editor Veronica Randall and my designer Brad Greene for this, our fourth book together.

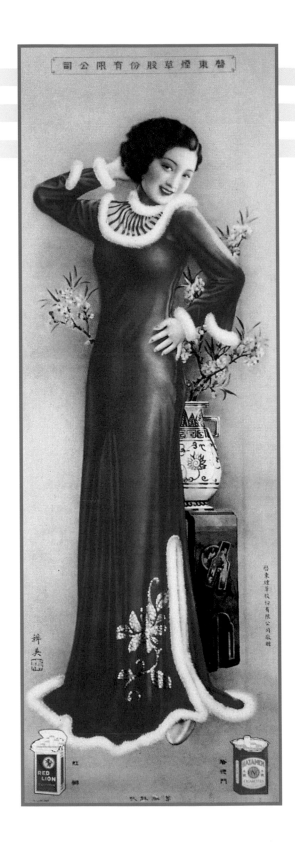

Frontispiece and cover: Hsu Bao-Gee (left), Qian Tong (center), and Lillian Yee (right) posing with a Pierce Arrow, owned by Liu Hao-Son, circa 1933. (Collection of Edith Liu.)

CONTENTS

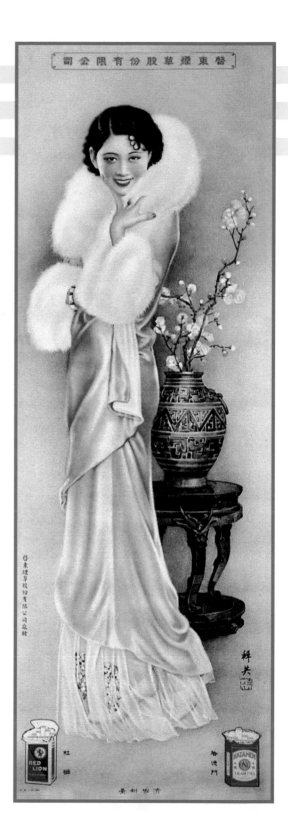

Foreword *vii*

PART I · THE CITY
Where East and West Met

Chapter 1 • An Accident of History 3

Chapter 2 • Magical Big Buildings that Reach the Skies 21

PART II · THE CLOTHING
Manchu Style to Madame Chiang

Chapter 3 • From Long Robes to the Republic 45

Chapter 4 • Calendar Girls and the Qi Pao 69

Chapter 5 • Working Girls as Fashion Icons 81

PART III · THE MOVIES
Star Power and Style

Chapter 6 • Femmes Fatale, Fashion, and Feminism 103

Chapter 7 • Anna May Wong: American Beauty and Asian Icon 131

Bibliography 143

Index 149

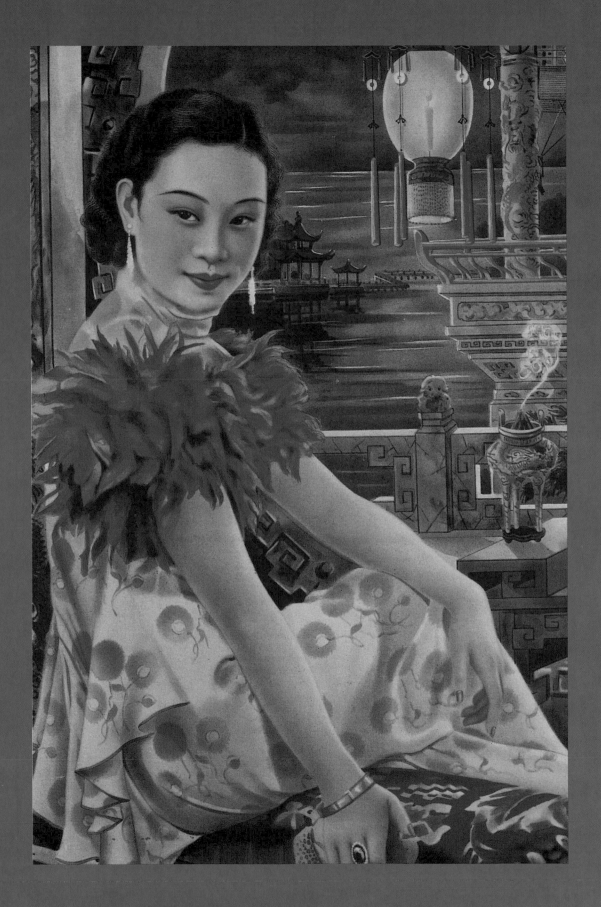

FOREWORD

SHANGHAI IN THE 1930s was an exciting city that still conjures up visions of glamour and evil, of gangsters and gambling, of gorgeous women and greedy warlords, of jewels smuggled from the Czar's court, of White Russian bodyguards riding on the running boards of bullet-proof limousines, of red-turbaned Sikh policemen guiding traffic between Art Deco skyscrapers and Western-style mansions, of rickshaws maneuvering the narrow lanes of the Native City. One never asked why someone came to Shanghai, because every foreigner was presumed to have something to hide.

By the early twentieth century, foreigners were flocking to Shanghai—and bringing their foreign influences with them. They came, they built, they bought, sold and traded, and they enjoyed a luxurious lifestyle virtually free of legal restrictions—no passports or visas required. They knew, of course, it could not last forever. And the legacy they left behind is a result of their indulgence—and their industry.

This book focuses on the Chinese women whose fortunes flourished and foundered with the fortunes of the city. It is not a comprehensive history, nor does it discuss the plight of all women in China. A wealthy Shanghainese, like the foreign Shanghailander, was quite capable of wrapping up in her furs and stepping unseeing over a ragged corpse dead from starvation and cold. They were "working girls" or women with fathers, husbands, or lovers who could afford their upkeep. So join me in visiting their world as the Shanghai girls get all dressed up.

★ A Shanghai beauty, circa 1930, wears an unusual gown with a high, Chinese-style collar, but feathered sleeves and bias ruffle at the back that are very Western and likely influenced by fashions seen in Hollywood movies.

PART I
THE CITY

Where East
and West Met

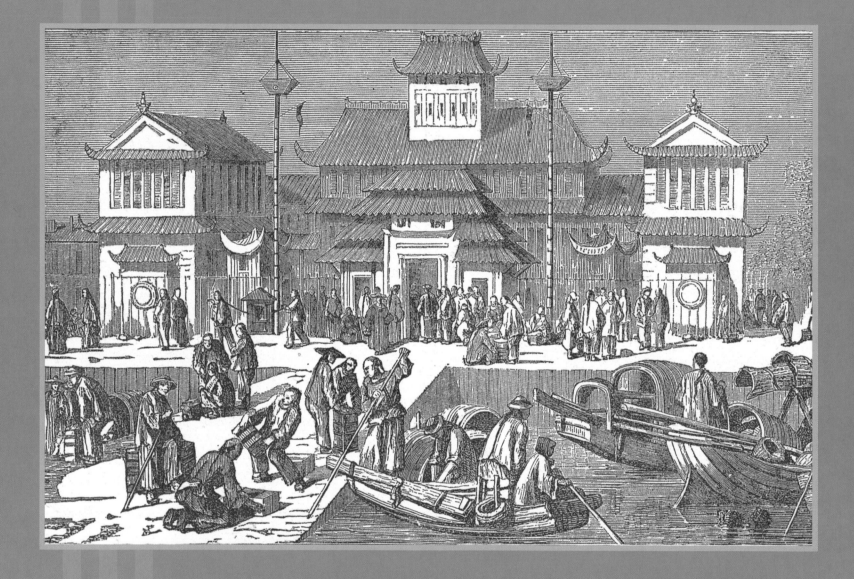

An Accident of History

"SHANGHAI, A HISTORICAL ACCIDENT,
WAS A UNIQUE SOCIAL EXPERIMENT. AS A SOCIAL FORM,
IT IS NOT LIKELY TO RECUR."

—H. J. Lethbridge, *All About Shanghai*

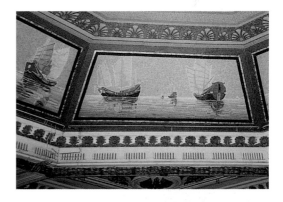

★ (Above) Delightful mosaics grace the ceiling of the Customs House commemorating the crucial contribution of the junk fleets that once plied Chinese waterways and transported cargo to foreign ports, making Shanghai a commercial capital. (Photograph by the author.)

★ (Opposite) Sampans crowd the waterfront at the old Customs House, circa 1891.

SAILORS KNEW when their ships were approaching Shanghai long before the skyline came into view. They knew because the color of the ocean changed from blue to brown at the confluence of the East China Sea and the Yangtze River. It still does. Shanghai, which means "up from the sea," was probably under water as recently as 2,000 years ago. The magnificent city we know today began as a nameless fishing village in the Tang dynasty (618–907 AD). Located on the eastern coast of China, Shanghai lies on the East China Sea, fourteen miles from the mouth of the longest and most important river in Asia, the Yangtze. The city is divided into two unequal parts by the Wusong River, a Yangtze tributary that becomes Suzhou Creek, an important waterway that passes through the heart of urban Shanghai.

★ The Bund, overlooking the Huangpu River and harbor, is a sophisticated thoroughfare that began as a muddy towpath along which Chinese laborers, or ku li (known by foreigners as coolies), hauled junks laden with rice and grain upriver. Named by the British, "bund" is an Anglo-Indian word meaning "river embankment," which evolved from a Hindustani word meaning "man-made embankment on a waterfront." The new Customs House, with its famous clock tower (left), was built in 1927 in the European neoclassic style used for many civic buildings. Another landmark on the city skyline, the Cathay Hotel (center) with its equally distinctive Art Deco pyramid tower, is called the Peace Hotel today.

THE BUND, SHANGHAI

During the Song dynasty (960–1272 AD) the nameless village grew into a bustling town called Shanghai. In the sixteenth century a wall was built around what had become a busy port and an important center for cotton production and shipbuilding. Flat-bottomed boats called junks, designed to navigate the shallow waters and treacherous sandbars of the Northern Ocean Channel, were crucial to Shanghai's growth. The junk commerce began in the Yuan dynasty (1279–1368 AD) and by the middle of the Qing dynasty (1644–1911 AD) a fleet of more 3,600 vessels transported cargo to distant ports, as well as all over China via an intricate canal system and made Shanghai the most important mercantile hub along the Southeast Sea.

Shanghai opened to the West in 1842 as one of the five treaty ports awarded to Great Britain with the Treaty of Nanking following China's defeat in the Opium Wars. During the seventeenth and eighteenth centuries foreign merchants were importing opium for use by the Chinese. By 1800, in an

attempt to stem the rising tide of opium addiction, the Chinese imperial government had prohibited its importation. But there was no stopping the trade—or the profits. Most of the opium was grown in India and Turkey, and British, European, and American traders found ways to smuggle it. By the 1830s more than 30,000 crates, each holding 150 pounds of opium extract, (totaling 4.5 million pounds) were entering China illegally each year.

War with the British erupted in 1840 following the confiscation and burning of British opium deliveries in Canton. Hopelessly outmatched militarily,

★ Sampans still crowd Suzhou Creek in the 1930s.

the Chinese were defeated. The resulting Treaty gave Hong Kong to Great Britain, and other coastal ports were opened to British residence and trade. The Treaty read, in part: "His Majesty the Emperor of China agrees, that British subjects, with their families and establishments, shall be allowed to reside, for the purposes of carrying on their mercantile pursuits, without molestation or restraint, at the cities and towns of Canton, Amoy, Foochowfoo, Ningpo and Shanghai; and Her Majesty the Queen of Great Britain, etc., will appoint Superintendents or Consular officers, to reside at each of the above-named cities or towns, to be the medium of communication between the Chinese authorities and the said merchants, and to see that the just duties and other dues of the Chinese Government, as hereafter provided for, are duly discharged by Her Britannic Majesty's subjects."

After the signing, other trading nations were quick to seek the same advantages the British had won. In July of 1844 Caleb Cushing, a member of the House of Representatives from Massachusetts, was sent to China by President Tyler. After 208 days at sea, Cushing and his companions landed at Macao in February 1844 where they waited two and a half months for the emperor's permission to proceed to the capital. Permission never came and they were forced to remain in Macao and negotiate with the Commissioner Ch'i-ying who had negotiated the English treaty two years earlier.

Finally, on July 3, 1844, the two men came to an agreement. Interestingly, Cushing never actually set foot on Chinese soil. The Treaty of Wanghsia was signed at Macao, a territory leased by China to Portugal, and gave the United States open trade with the five ports awarded to the British, along with a residence of consuls, most-favored-nation and extraterritoriality provisions, which placed Americans in China under American consular jurisdiction. Thus,

the citizens of the "most favored nations" were accountable to, and could only be tried in, their own courts or consulate. This brief clause in the treaty called "extraterritoriality" allowed every American to act with impunity since it made him and his property immune from Chinese law. And it excluded Americans from becoming involved in Chinese conflicts. Not every foreigner, however, enjoyed this special status. White Russians, for example, who entered China without passports or other official identity papers could not benefit from the extraterritoriality granted to other foreigners. They were subject to Chinese laws, courts and prisons.

In 1842 the British were allotted a portion of land on the south side of Suzhou Creek. The French Concession was established in 1849 on the Huangpu River between the walled Chinese City to the south and the British Settlement to the north. The Americans leased land several years later along the Huangpu waterfront north of Suzhou Creek. However, in 1863 they incorporated with the British, creating the International Settlement, which was governed by a select group of Americans, British and Japanese known as the Municipal Council. The French Concession, which grew eventually to nearly 400,000 inhabitants, remained independent and was governed and policed by its own seventeen-man council. The Chinese living in the International Settlement faced what was called the Mixed Court for offenses committed within the Settlement limits presided over by a Chinese magistrate and a foreign consular representative.

Thus, the foreign communities of Shanghai were not colonies per se of any particular countries or foreign powers. They were self-governing entities unto themselves. Not surprisingly, the Municipal Council members were among the most affluent residents in the foreign concessions. The fact that

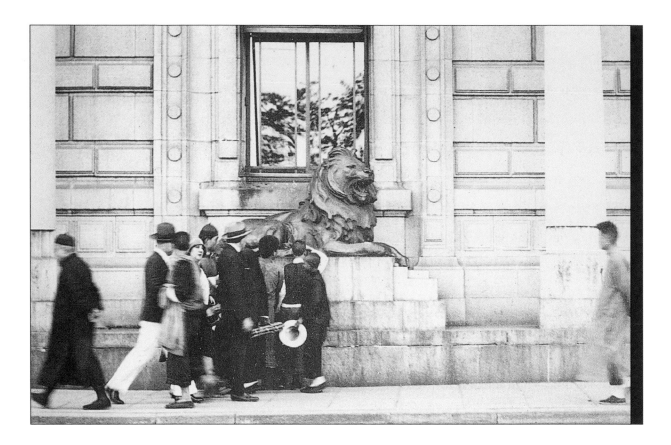

★ The Bund was where many of the great civic and commercial buildings were erected from the turn of the century through the 1930s. The grandest of these still standing is the Hong Kong and Shanghai Bank adjacent to the Customs House. Built in 1923, it was the second largest bank building in the world at the time. Restored to its original neoclassic splendor, today it houses the Shanghai Pudong Development Bank. Flanking the massive front doors, a pair of magnificent bronze lions (stored safely in the basement of the Shanghai Museum for the duration of the Cultural Revolution, 1966–1976) guard the entrance and greet customers. It was, and still is, a custom to rub the lions' paws for good fortune.

these Shanghailanders, an elite cadre of successful businessmen, controlled their own economic destinies with virtually no interference from local Chinese authorities, or restrictions from interests "back home" in their nations of origin, made Shanghai a capitalist's paradise.

It must be said that free enterprise flourished not only on a legitimate level, but the unique system of independent governing bodies described above made Shanghai a haven for a criminal element that could move freely among the concessions. For example, if things got too hot with Chinese authorities, one could seek refuge in, say, the French Concession where Chinese law enforcement had no jurisdiction. Or vice versa. And this is precisely what happened. A gangster class emerged that operated with impunity throughout the city.

The most notorious gangster of the 1930s was Du Yuesheng, nicknamed Big Ears Du for apparently obvious reasons. Born into poverty in 1887 across the Huangpu River in Pudong, Du joined the Green Gang, the top of the heap as Shanghai gangs went, at twenty and rose quickly through its ranks. He formed a partnership with Huang Jinrong, a senior officer with the French police, and between Du's cunning and ambition and Huang's powerful position, the two ran the entire French Concession. In *Sin City*, British journalist Ralph Shaw described him as "King of the Underworld, the opium magnate, the gangster chief whose terrible power was wielded over an empire of crime that out-ranged in evil even that of Al Capone in Chicago." In *Journey to a War*, W. H. Auden and Christopher Isherwood wrote, "Du himself was tall and thin, with a face that seemed hewn out of stone, a Chinese version of the Sphinx. Peculiarly and inexplicably terrifying were his feet, in their silk socks and smart pointed European boots emerging from beneath the long silken gown"

However, despite his formidable reputation, it seems Du was civic-minded and contributed generously to his community. According to *Shanghai Who's Who 1933*: ". . . Entered business at an early age. At present, most influential resident, French Concession. Well-known public welfare worker. 1932 councilor, French Municipal Council. President, Chung Wai Bank, and Tung Wai Bank. Founder and Chairman, board of directors, Cheng Shih Middle School. President, Shanghai Emergency Hospital. Member, supervisory committee, General Chamber of Commerce. Managing Director, Hua Feng Paper Mill. Director, Commercial Bank of China, Kiangsu and Chekiang Bank, Great China University, Chinese Cotton goods exchange, and China Merchants Steam Navigation Co., Shanghai. President, Jen Shi Hospital, Ningpo."

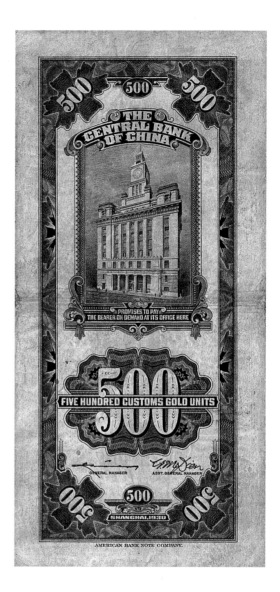

★ Bank note, circa 1930, featuring the clock tower—the Big Ben of the Far East—above the Customs House. During the Cultural Revolution its melodic bell works were replaced with forty loud speakers that brayed a political song of the day, "The East is Red." The bell works are back in place peeling out the hours once again.

★ This spacious villa in the French Concession once belonged to Du Yuesheng, Shanghai's most notorious gangster of the 1930s. It is now a hotel. (Photograph by the author.)

★ It was generally agreed that the French Concession was the most glamorous of the foreign districts, with elegant villas, fine restaurants, fashionable shops, and shady streets, like this one lined with plane trees imported from France. (Photograph by the author.)

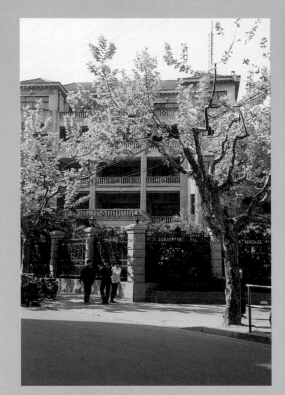

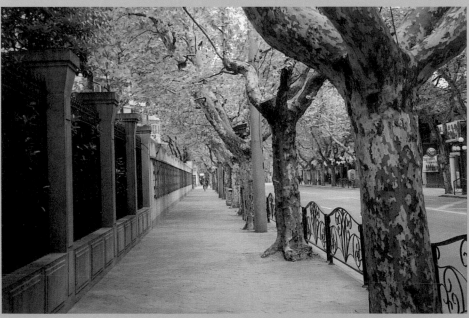

★ Lush gardens laid out in the European style in the French Concession surround the residential compound of H. E. Morris, owner of the NORTH CHINA DAILY NEWS, once the largest English-language newspaper in China. The compound has been preserved and is a hotel today. (Photograph by the author.)

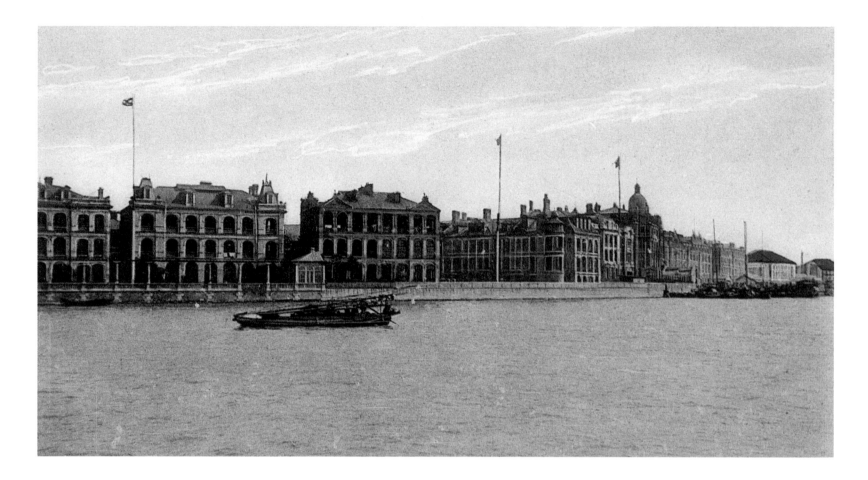

By 1925 the International Settlement, occupying 8.7 square miles of Chinese territory, was home to approximately 30,000 foreigners and 810,000 Chinese. The French Concession figures from the period record 8,000 foreigners and 297,000 Chinese. The Japanese population totaled 30,000 by 1932 and lived primarily in the Hong Kew area north of the Garden Bridge often called "little Tokyo." By the early 1930s, some 60,000 foreigners and 50 nationalities were recorded by the Shanghai census. And with them came an explosion of investing, building, and modernization.

Bicycles, sedan chairs, wheelbarrows, and rickshaws (brought to China from Japan in 1874 by a Frenchman) once shared the streets with horse-drawn

★ American, German, and Japanese consulates, circa 1900.

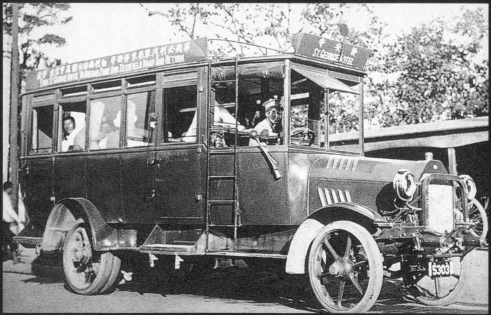

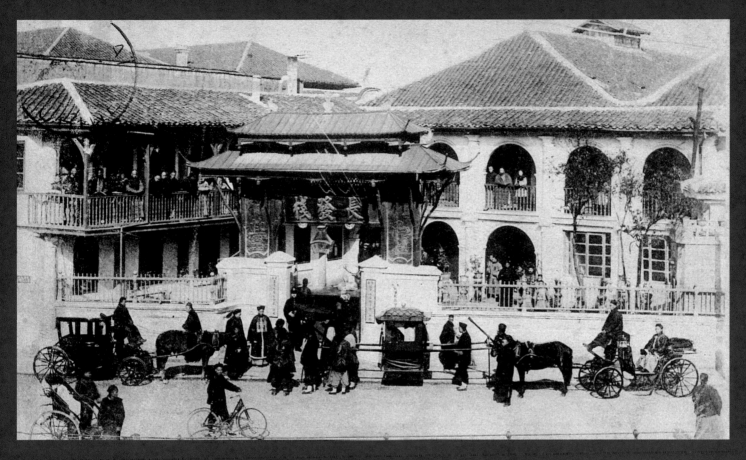

★ Horse-drawn carriages, sedan chairs, rickshaws, and bicycles pull up outside a Chinese hotel, circa 1906.

★ By 1918, Shanghai had a tram line, although this streetcar shares Seward Road with the ubiquitous rickshaw (left) and wheelbarrow (right).

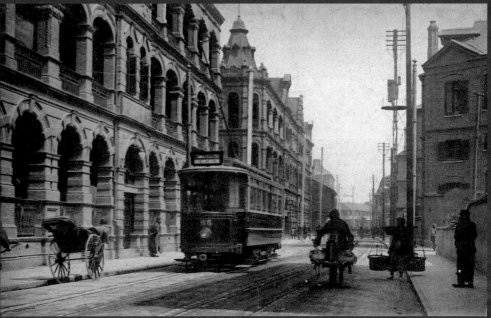

★ Sikh policemen were hard to miss even on a crowded street because they were usually very tall, and made more so by their distinctive red turbans.

carriages. By the 1920s imported automobiles—Talbot, Bugatti, Citroen, Renault, Peugeot, Salmson, and Delahaye—conveyed bankers, brokers, developers, diplomats, gangsters and warlords, their wives and mistresses. Shanghai's tram system started up in 1918. In 1922 an inventive Chinese merchant joined two passenger vehicles turning them into a bus, and in 1924 a British-owned company began operating regular bus lines.

In addition to new mass transportation within the city came new modes of communication—and competition. By 1881 the Great Northern Telegraph Company of Denmark had installed twenty-five telephones in the International Settlement, with public phones and a telephone office the following

★ American and European residents imported
expensive automobiles which also became the
ultimate status symbols for wealthy Chinese.

★ (Right) Entrance to the Old City through a 16th-century gate.

★ (Below) The Native City separated from modern Shanghai by the 16th-century wall.

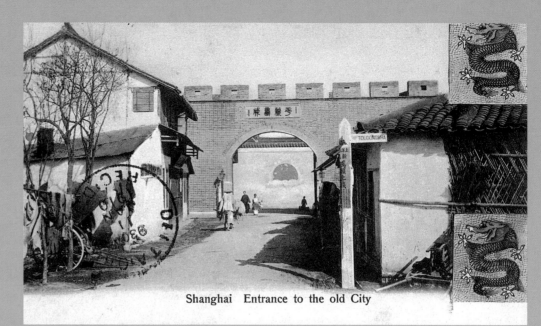

Shanghai Entrance to the old City

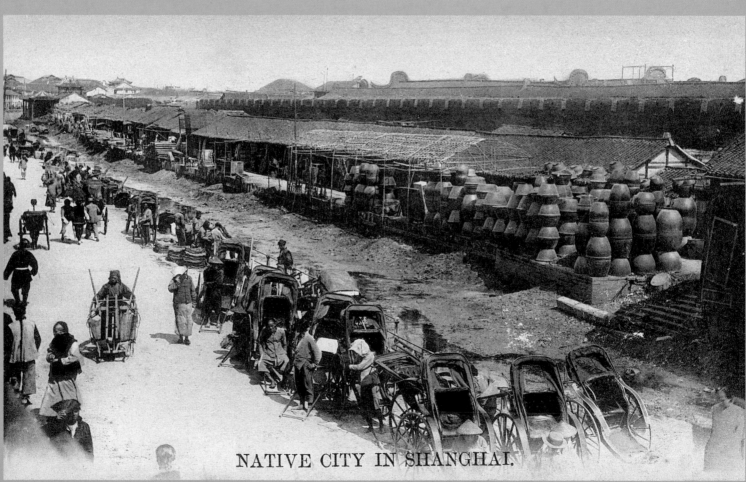

NATIVE CITY IN SHANGHAI.

year. But by 1930 the American-Shanghai Telephone Company had gained the monopoly in the International Settlement.

As modernization progressed rapidly through the foreign districts, change happened more slowly in the rest of Shanghai, also known as the Old City or the Native City. Until 1912, this area was completely surrounded by a wall built in 1533 as protection against Japanese pirates. Entering through the Great East Gate, a foreigner visiting the Native City, which very few ever did, would be faced with a crowded and confusing tangle of streets, known as *longtang*, where few modern influences were to be found. The longtang were too narrow and too crowded for anything larger than a wheelbarrow or rickshaw.

At the beginning of the twentieth century, foreign developers were forced to build housing in the International Settlement and the French Concession to accommodate the burgeoning population of Chinese workers needed for the economic boom that was taking place in Shanghai. These areas became known as *shikumen* territory. The word "shikumen" translates as "stone-framed-door houses" and the name evolved from of the ornately carved stone arches above the doorways and entry gates.

Each *lilong* or housing block consisted of usually two-story brick, European-style row houses, built around a small courtyard. Basins or small tubs were filled from a central water source in the courtyard. Chamber pots with lids were set out next to the shikumen gates for the night soil collector who came with his cart in the early morning.

Many Chinese were born and lived their whole lives in the same lilong. And the longtang was where much of their socializing transpired. Residents exchanged news and gossip with their neighbors while playing mahjong or cards. This way of life continues in shikumen districts that remain today.

★ The distinctive decorative arches above doorways and entry gates in the shikumen districts were elaborately carved and lent an air of affluence to cramped living quarters. Xintiandi District. (Photographs by the author.)

★ A longtang in the restored Huai Hai' Lie district, with decorative arches visible at left. (Photographs by the author.)

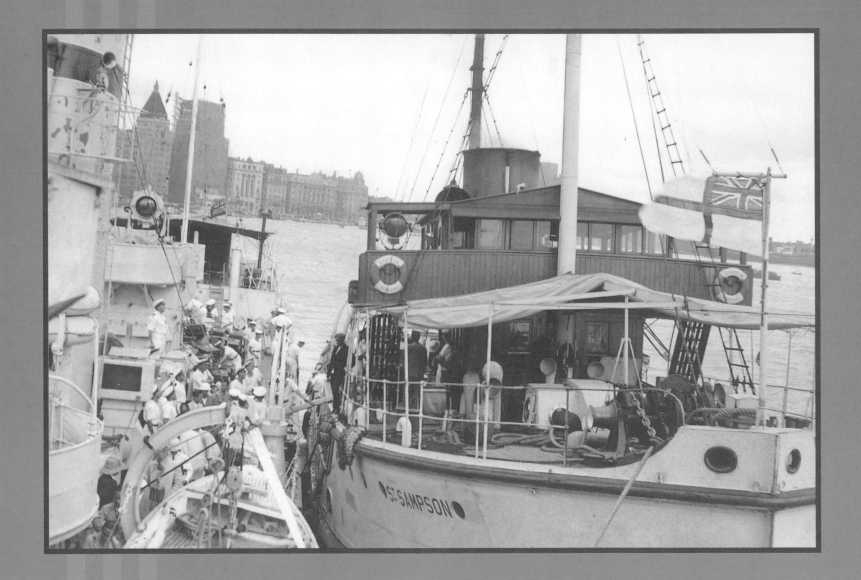

Magical Big Buildings that Reach the Skies

"A SHANGHAI BUILT BY FOREIGNERS FOR FOREIGNERS IN THE STYLE OF A COUNTRY FROM WHICH THEY CAME AND TO WHICH THEY WOULD ULTIMATELY RETURN."

—Tess Johnston, *A Last Look: Western Architecture in Old Shanghai*

THE ECONOMIC OPPORTUNITIES available in Shanghai touched off an explosion in foreign building. And the new civic, commercial, and residential structures looked nothing like the indigenous architecture of the Native City. No swooping swallowtail roofs or glazed tiles to catch the afternoon sun. No moon gates or spirit screens. No vermilion lacquered pillars or intricate latticework windows. No narrow longtang meandering through a maze of windowless walls. The colonial neoclassical style the British employed in the first decades of the century, and the sky-scraping Art Deco designs favored by the Americans in the late 1920s, were totally alien to the environment, and to the native population. The Chinese called them *motian dalou* (magical big buildings that reach the skies). They were banks, clubs, hotels, theatres, apartment blocks, office buildings, and department stores.

★ (Opposite) August 1937. British women and children were transferred from the ferry boat Sampson to the H.M.S. Duncan that will carry them back to England. The Cathay Hotel (left) in the background.

★ By contrast, foreigners lived in spacious villas, comfortable bungalows, or imposing apartment blocks. Grosvenor House, French Concession, opened in 1931, built by Sir Victor Sassoon.

More significantly, they were part of another world, a world that represented success in Western terms, and a world that was often off limits to many Chinese, unless they were employees.

Among the largest employers were the palatial European-style hotels. The Palace Hotel went up in 1906 and boasted a fabulous display of fine marbles, crystal chandeliers, and rare woods. When the 24-story Park Hotel opened in 1934 it was, at 82 meters high, the tallest building in Asia. Its famous Sky Terrace on the top floor had a roof that rolled back, making it a great favorite

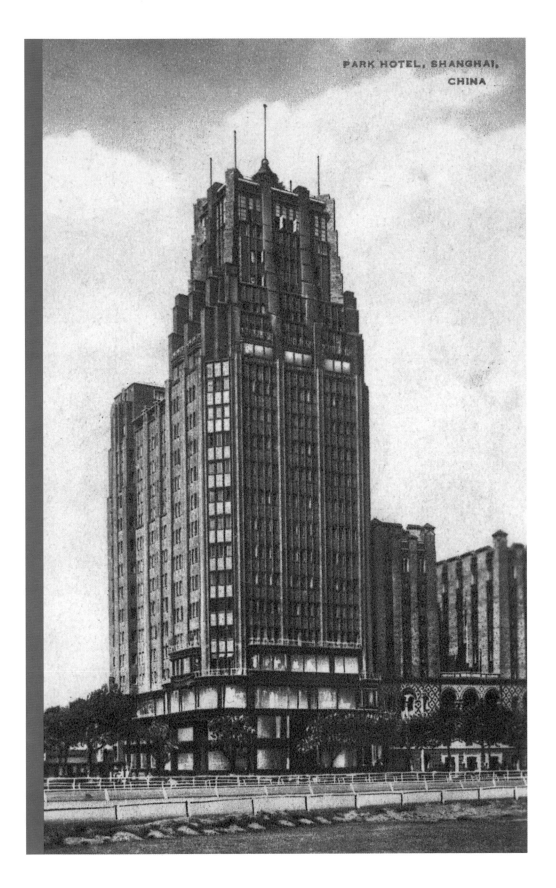

PARK HOTEL, SHANGHAI, CHINA

★ The Park Hotel was designed by Czech born, Hungarian trained Ladislaus Hudec who, in 1916, had been captured by the Russians and sent to a Siberian labor camp. After two years in the gulag, he escaped, ultimately arriving in Shanghai where he joined an American firm, R. A. Curry. In 1925 Hudec opened his own architectural offices and achieved great success in his adopted city. The Park Hotel is one of his crowning achievements.

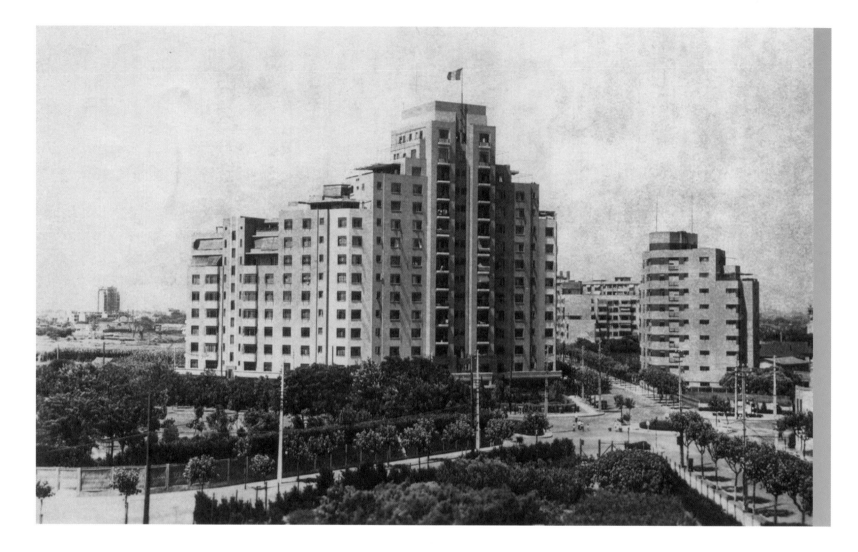

★ Gascoigne Apartments, French Concession, 1934, was known for its enormous coal-burning furnace that was fed 24 hours a day by stokers.

among the international set. Few Chinese could afford to stay in these modern architectural marvels.

The most famous hotel in Shanghai was the Cathay, built by Sir Ellice Victor Sassoon, a Cambridge educated Iraqi millionaire of Jewish faith who arrived in Shanghai from Bombay in 1931. This slightly lame (the legacy of an airplane crash during World War I when he was a captain in the Royal Air Force), be-monocled, witty, and tremendously wealthy man had a family history equally as colorful as his personal past.

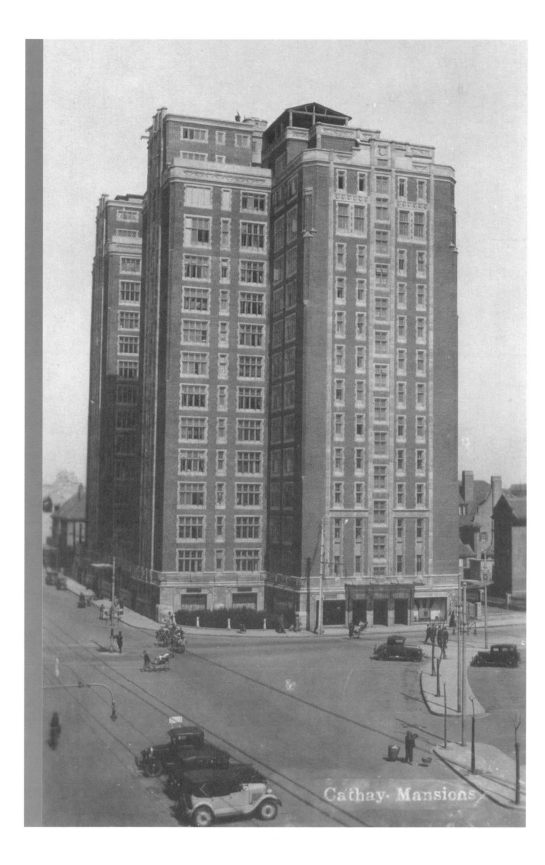

★ Cathay Mansions, French Concession, 1928, built by Sir Victor Sassoon.

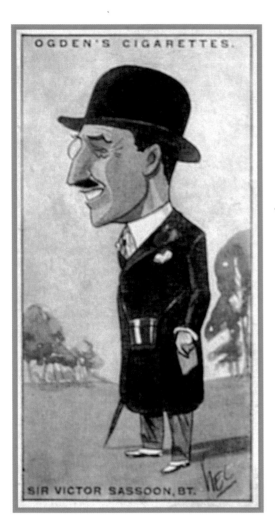

OGDEN'S CIGARETTES.

SIR VICTOR SASSOON, BT.

★ Sir Victor Sassoon had a great love for horse-racing. Using the name Mr. Eve, he raced in India and spent tremendous sums of money on English bloodstock that he later transported to China. (From TURF PERSONALITIES, 1928.)

In 1835, Sir Victor's grandfather David Sassoon left Baghdad and settled in Bombay where he established David Sassoon and Sons, exporting cotton and opium so successfully, his eldest son Albert was honored by Queen Victoria with a baronetcy for his contributions to India's prosperity! In England the Sassoons lived very grandly and were welcomed into top society. King Edward VII was a frequent houseguest at their country estate Tulchan Lodge in Speyside.

It was bitterness over British taxes that ultimately led Sir Victor first to the British Crown Colony of Hong Kong, where he incorporated his companies. From there he transferred millions to Shanghai, where he invested in land along the Bund, a courageous move in 1927. No more than ten stories was the height limit along the muddy, unstable embankment. But clever Sir Victor sank hundreds of Douglas fir trees into the mud, then laid a concrete raft on top of them. Atop this foundation rose the luxurious twenty-story Cathay Hotel. The architectural firm of Parker and Turner spared no expense on the Cathay's superb black and cream marble lobby, or the elegant ballroom with its Lalique glass wall sconces and white maple dance floor.

The Majestic Hotel, opened in 1926, had once been a private residence built by an eccentric Englishman called Captain McBain for his Chinese bride. The Majestic's ballroom, the largest in Shanghai, was where General and Mme. Chiang Kai-shek held their wedding celebration for 1,300 guests on December 1, 1927. It was also where the White Russian residents of the city held their annual Russian Ball. Many of these formerly aristocratic émigrés lived in gentile poverty, but at least one night of the year they could relive, and revel in, a once glamorous Czarist past.

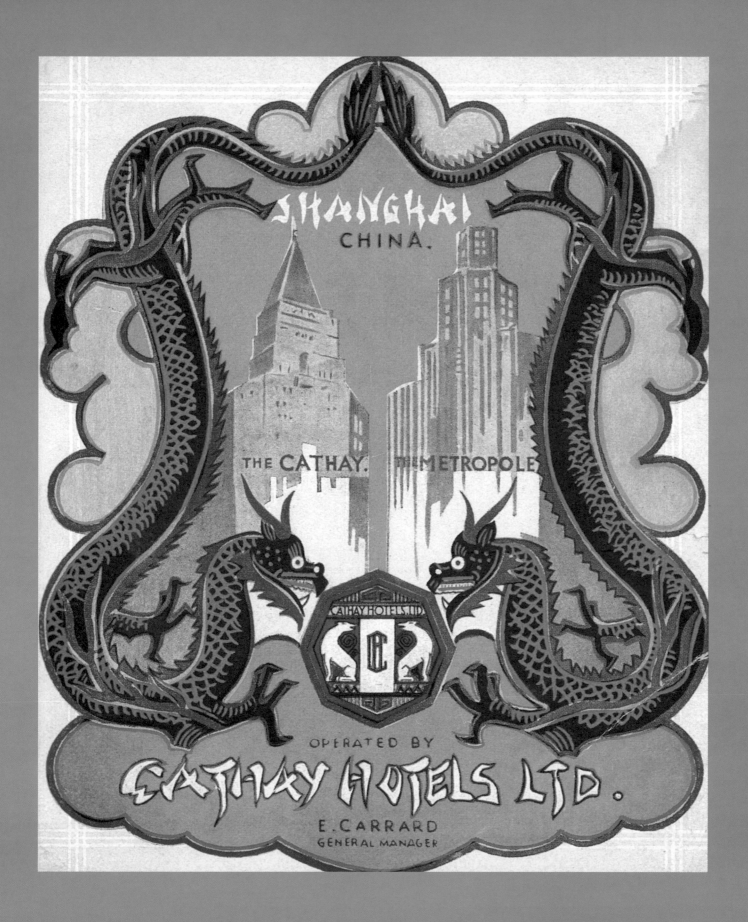

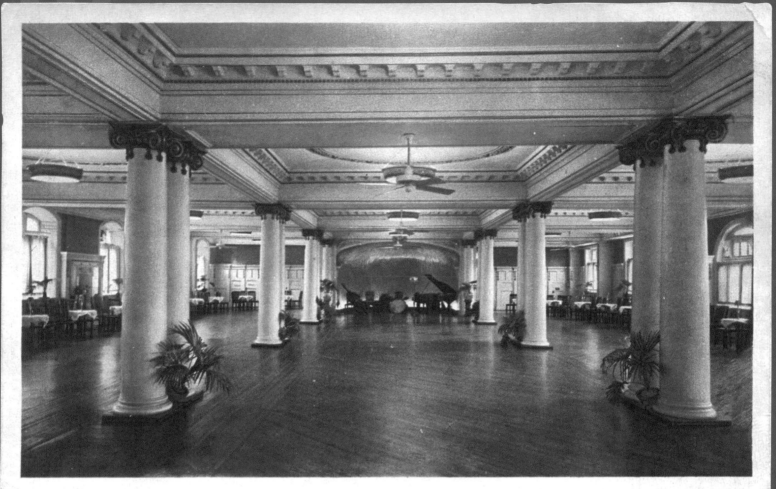

★ Astor House Hotel ballroom.

★ The Astor House Hotel was the first well-known Western-style luxury hotel in China. Run by foreign businessmen, Astor House was where the rich or famous (or both) stayed when they visited Shanghai. Luminaries included President Ulysses S. Grant, Albert Einstein, and Charlie Chaplin. Astor House was also the site for a number of China's important technological "firsts," including the installation of the first telephone in the country, and the lighting of it's first electric light. Astor House is located on the Huangpu River north of the Bund.

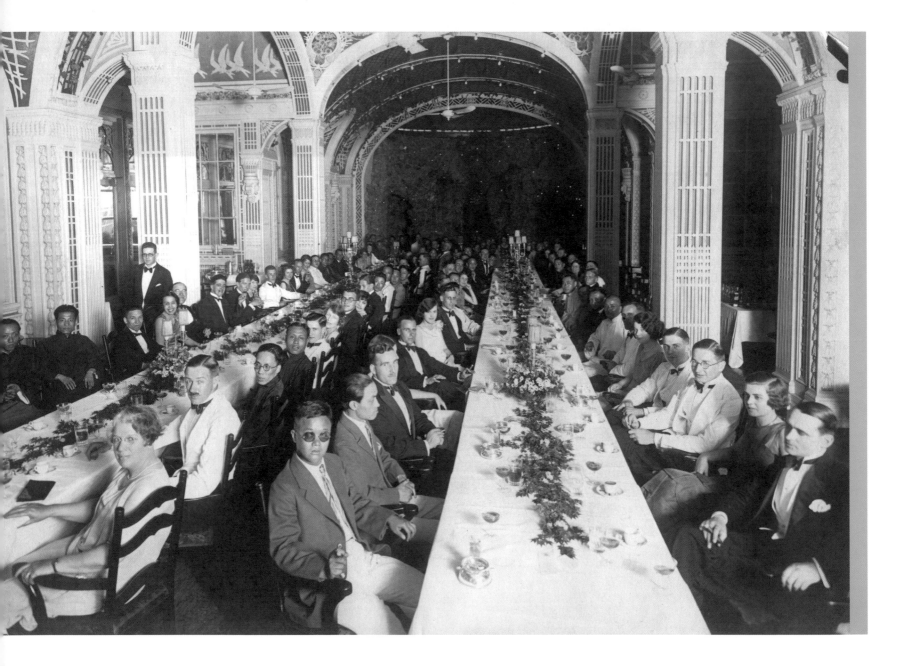

★ Dinner party at the Majestic, circa mid-1930s.
It is interesting to note that several Asian guests,
possibly Japanese or Malaysian (center), wore
Western attire while the Chinese guests (far left)
stayed with traditional pu fu.

MAJESTIC HOTEL

SHANGHAI.

August
Thirty-First
1927

★ Majestic Hotel ballroom and menu, 1927.

WINES:

Cocktails

Sherry

Oppenheimer 1921

Louis Roederer

Liqueurs

Cigars & Cigarettes

MENU

Astrakan Caviar Sur Socle

Olives Celery Almonds

Consomme Belle Vue

Lobster Thermidore

Tournedos Majestic

Roast Pheasant
Souffle Potatoes

American Lettuce & Asparagus Tips
Thousand Island Dressing

Bombe Frascati

Petit Fours

Demi Tasse

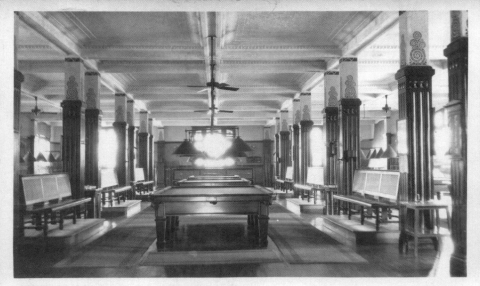

CERCLE SPORTIF FRANCAIS Le Billard Billiard Room A. Léonard, P. Veysseyre Architectes.

★ Ciro's was built by Elly Kadoorie who, like Sir Victor Sassoon, was of Iraqi Jewish heritage and was one of the wealthiest men in Shanghai. His fabulous home is now the Children's Palace. Ciro's was the most expensive of the leading nightclubs in Shanghai. Now demolished.

★ The billards room, Cercle Sportif Française.

In addition to the grand hotels, social and sporting clubs, of which there were some 200 by the end of the 1930s, were the most popular gathering places for the Shanghailanders. The British are generally thought of as the leading club organizers, but it was the Danish Reading Society, a lending library founded in 1885 that evolved into the first international community club. The Americans had another important first. Built in 1924, theirs was the first foreign club to open its doors to Chinese members. Thus, in addition to luxuriously appointed billiards and card rooms, a mahjong room was added. The ancient game of mahjong was destined to become quite popular among Westerners, and remains so to this day. As was typical of the times, women were not allowed membership, however, they could attend "Ladies Night" once a year.

The Shanghai Club, located in the Bund, was originally built by the British in 1861. Rebuilt in 1905, it was the most prestigious club in the Far East. Although considered by some to be conservative and stuffy, it was famous for having the world's longest bar—a staggering 33 yards! The Cercle Sportif Française, designed by Paul Veysseyre in 1926, boasted a magnificent oval ballroom and an Olympic-sized swimming pool beneath a three-story ceiling, several fine restaurants, as well as an unusual horseshoe-shaped bar. And while other clubs barred women, the Cercle welcomed them as members. Well, they welcomed forty women at a time! Needless to say, there was always a long waiting list for membership.

Greyhound dog racing became so popular in Shanghai during the late 1920s and throughout the 1930s the city boasted three stadiums. The largest was the Canidrome, which opened in 1928, and had seating capacity for 50,000 spectators. Each track had a members' club and because the race meetings usually took place at night, dining and dancing were popular features.

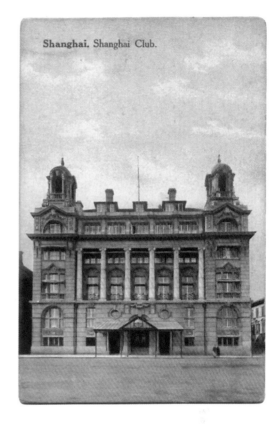

★ The original Shanghai Club.

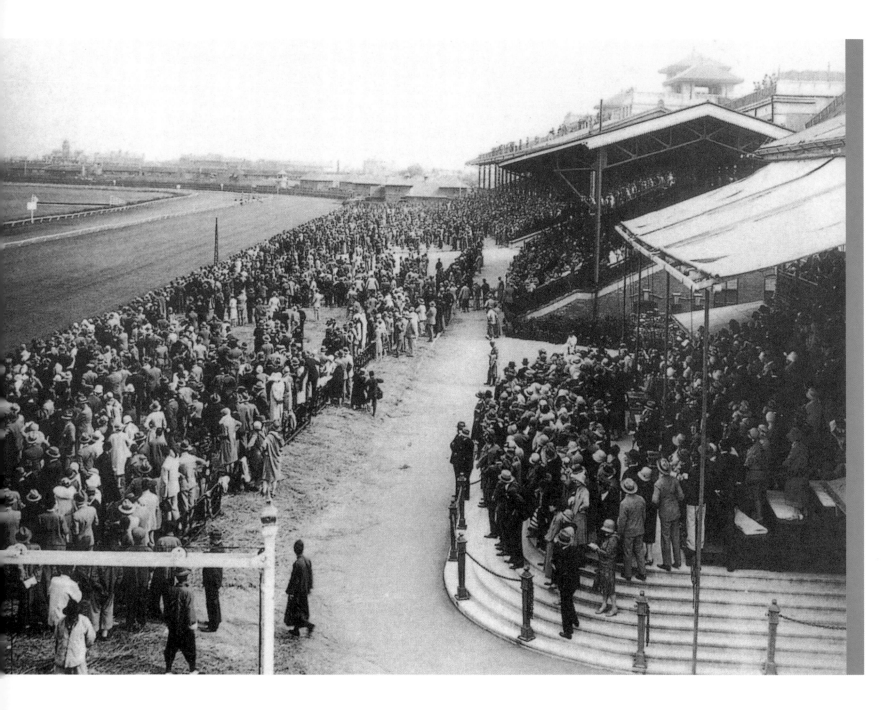

★ Horse racing was so important in Shanghai, offices closed on major race days, circa late-1920s.

Horse racing was established in Shanghai in 1862 and became the city's most prestigious sporting event. And not surprisingly, the Shanghai Race Club was the city's most socially desirable membership. Although women

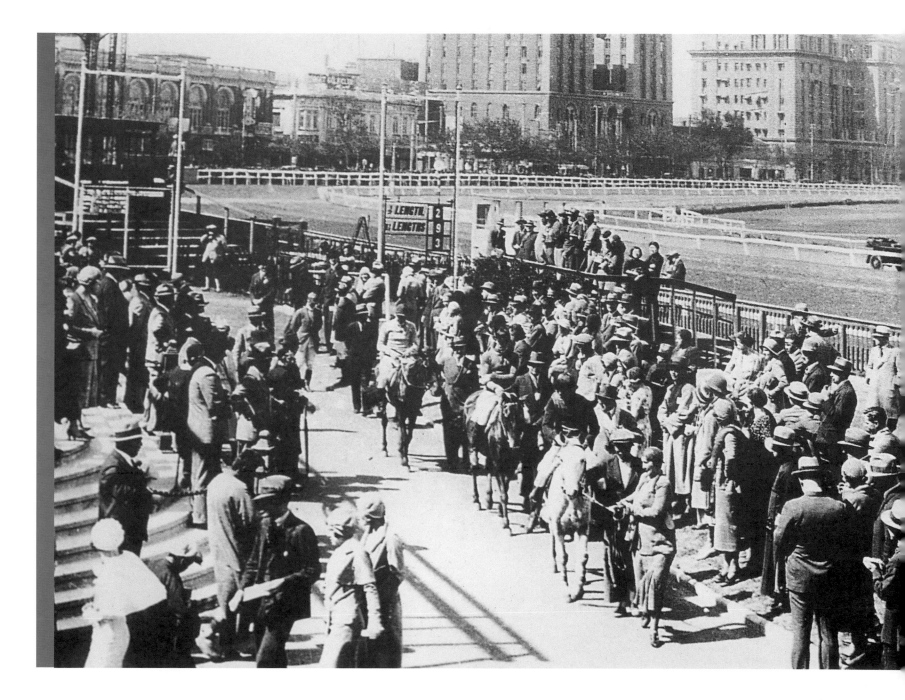

could not enter the club, they could attend parties in the members' private boxes in the viewing stands at the track. The Chinese were also excluded from membership to the Race Club, so in 1911 two Chinese entrepreneurs opened

★ A proud European owner brings in her winner, circa 1930.

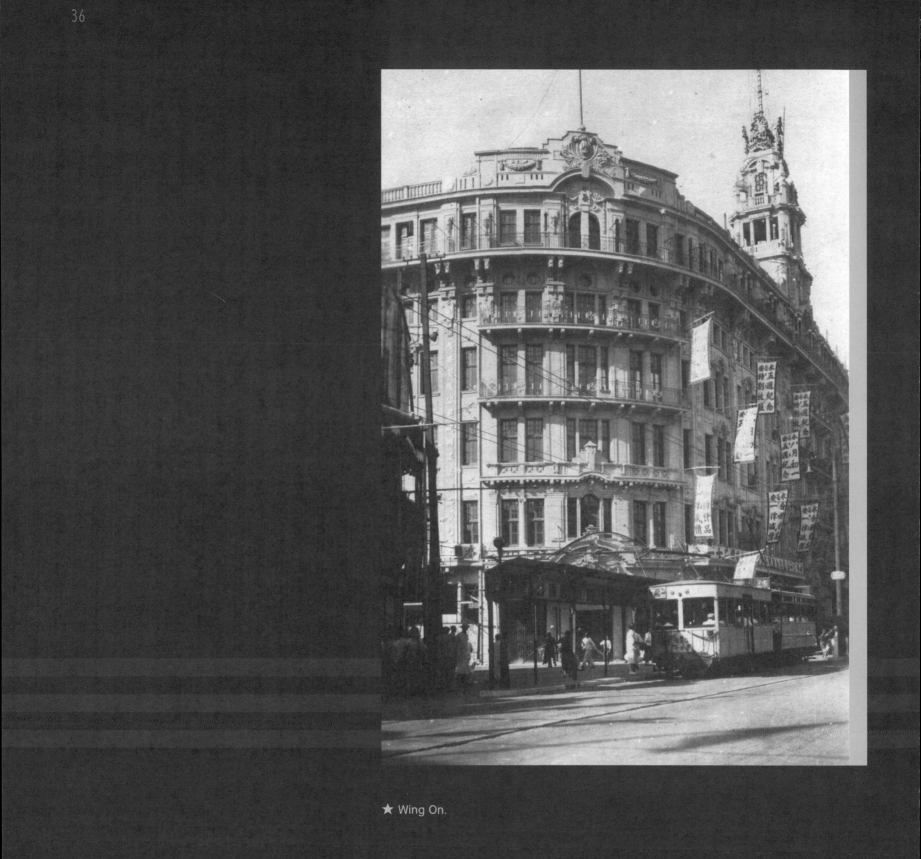

★ Wing On.

SENG CHUN & CO.,
A 1295, Broadway, Corner of Wuchang Road.
Tel. No. 42289
SHANGHAI.

Manufacturers & Exporters of
Lady's Silk Underwear, Pyjama, Kimono, Haoricoat,
Mandarin Coat, Canton Shawl, Embroidery,
Drawn Work, Lace, Cross Stitch,
Also Dealers In
Ivory, Bead, Foochow Lacquer, Silver Wear, Cloisonne,
Nanking Tapestry, Pewter wear, Old Embroidery,
Crepe de Chine, Silk, Pongee, Linen, etcs.
Whole Sale & Retail.
INSPECTION WELCOME.

WAH SHING
LADIES TAILOR & DRESS
MAKER
Clother And General Outfitter Fur.
Skin And Embroidy Millirery
No. F. 1870 Bubbling Well Road.
SHANGHAI

★ Business cards for specialty goods merchants catering to customers, foreign and Chinese, who did not want ready-to-wear clothing but preferred to buy exquisite fabrics for their handmade suits, gowns, furs, lingerie, and millinery.

their own racecourse and club—at which foreigners were graciously accepted as members!

A Mecca for both the Shanghailanders and for well-to-do Shanghainese was Nanjing Road. The International Settlement's busiest commercial area in the 1930s boasted four lavishly appointed department stores: Sun Company, Sincere Company, Sun Sun, and Wing On. In a city where the purchase of any goods—regardless of size, quality, or intrinsic value—required protracted bargaining, the Sincere Company introduced the notion of a fair, fixed retail price for each item on sale. It also innovated a diversity of merchandise offered in place of the traditional individual specialty vendor, and was the first to hire a staff of sales girls.

By the late 1920s, Shanghai had become a city bright with neon that shouted out the names of its new movie palaces: Metropole, Lyceum, Cathay,

★ While a dizzying selection of merchandise was readily available in the huge department stores, the highest quality made-to-order goods came from smaller establishments. Lotte and Albert Leyser, immigrants from Berlin, ran a bustling shop that specialized in artificial limbs and orthopedic appliances. Their products were much in demand thanks to feuding gangsters, lively warlords, and China's seemingly endless on-going wars, great and small.

Paris, Odeon, Grand, Astor, Capitol, Golden Gate, Ritz, Roxy, Star and many more. The Grand, designed by Ladislaus Hudec, could accommodate an audience of 2,000 and was, like so many other buildings that went up all over the city, a shrine to the Art Deco aesthetic. The Grand, in particular, owed much to the American influence of New York's Chrysler Building, Rockefeller Center's Radio City Music Hall, and Waldorf Astoria Hotel in both the shape and scale of its rooms, in the decorative geometric designs in its marble flooring, ironwork banisters, radiator covers, and elevator doors, and in its innovative recessed ceilings and lobby with newly invented neon lights.

Cinemas were also found in amusement halls such as Great World, 14,700 square meters of adult entertainment that opened in 1917. Famed film director Josef von Sternberg, wrote in his autobiography, *Fun in a Chinese Laundry*, a description of Great World that included: gambling halls, magicians,

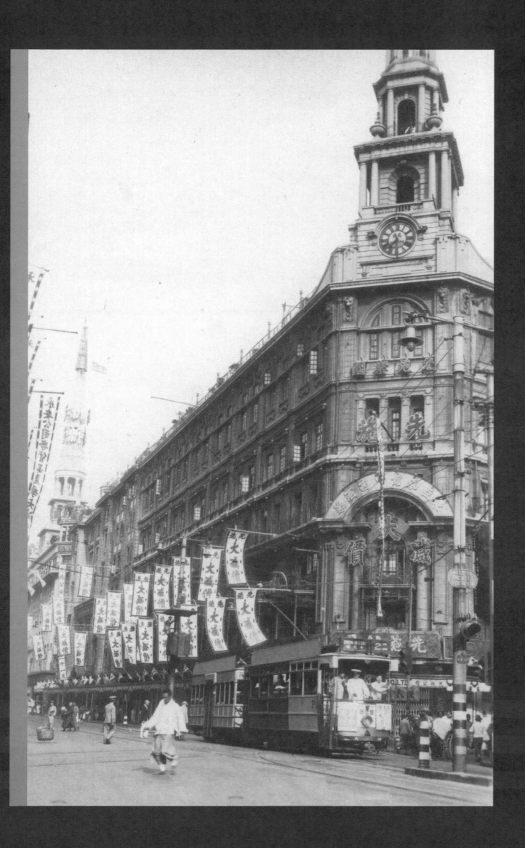

★ Sincere Company.

★ Nanjing Road.

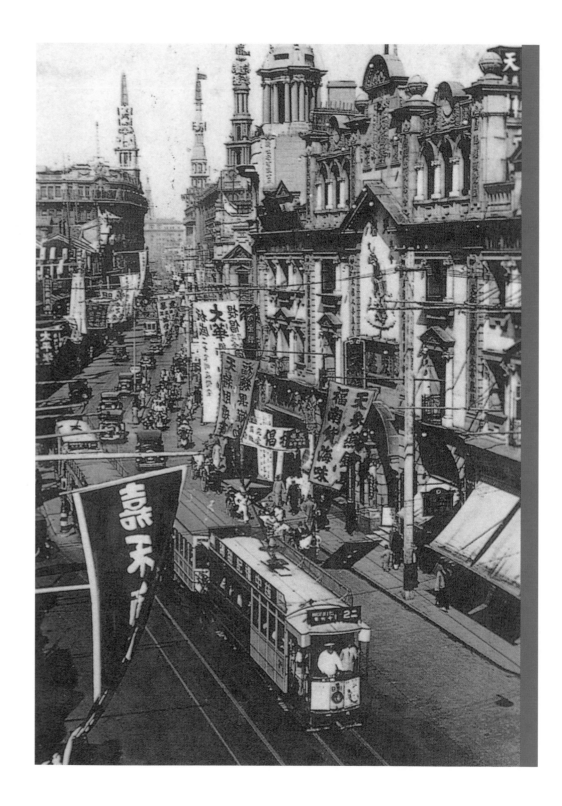

fireworks, pickpockets, acrobats, ballrooms, restaurants, midwives, barbers, pimps, jugglers, ice cream parlors, photo studios, shooting galleries, acupuncturists, prostitutes, taxi dancers, story-tellers, a stuffed whale, a mirror maze, a temple, two booths where scribes wrote love letters for the illiterate, marriage brokers, and ear wax extractors. And although he does not list it, the Great World movie theatre was still in operation in 2003.

In Shanghai, anyone with one or two *yuan* for a ticket to one of the big theatres could go to the movies. And those who didn't could go to one of the second- or third-rate houses where tickets were one-tenth the price, such as the Eastern, Broadway, and Wayside Theatres. Records from 1931 show twenty-four cinemas in the International Settlement and twelve in the French Concession. The number of theatres in the Chinese City was not recorded, however, it is known that during the Japanese bombing of Chapei and Hong Kew districts in 1932 at least sixteen movie houses were destroyed.

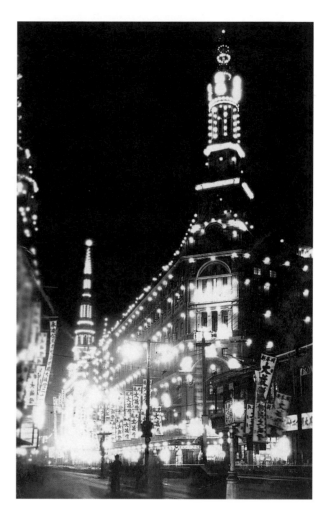

★ Nanjing Road after dark with the illuminated spire (left) above Great World.

PART II
THE CLOTHING

Manchu Style to
Madame Chiang

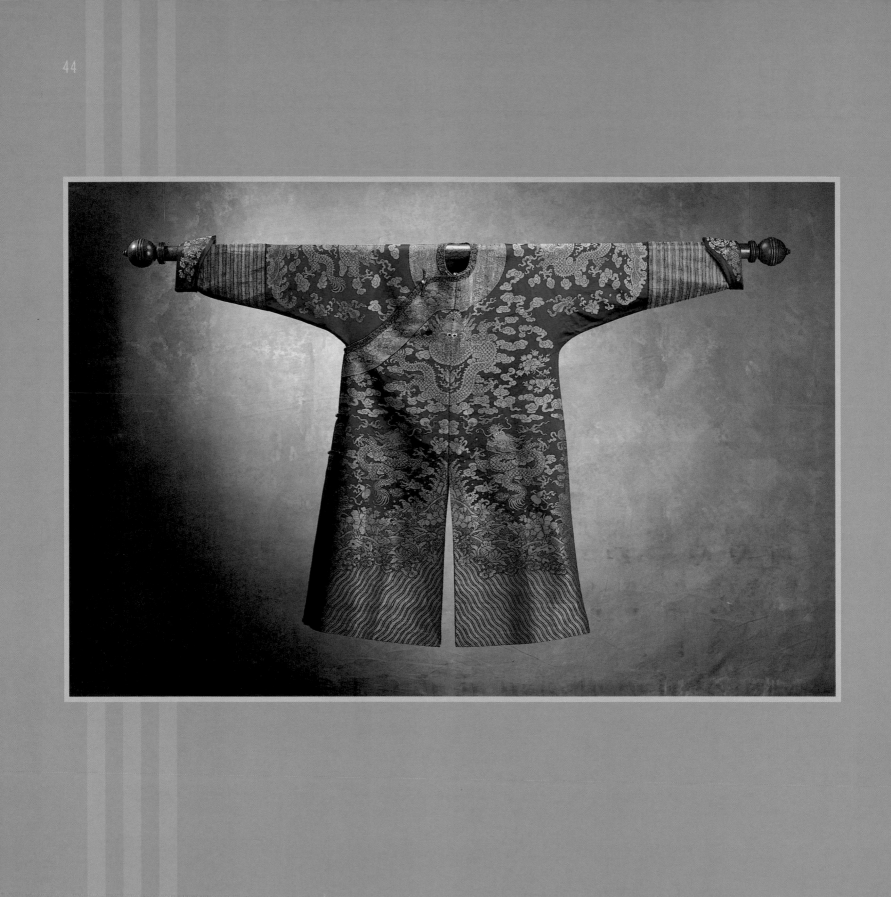

From Long Robes to the Republic

". . . MANCHU DRESS BECAME [A] SYMBOL OF THE AUTHORITY OF
A SMALL GROUP OF NOMADIC WARRIORS OVER A MUCH LARGER
CHINESE POPULATION. BY IMPOSING THEIR NATIVE COSTUME ON ALL
GOVERNMENT SERVICE, THE MANCHU BOTH ACKNOWLEDGED THEIR
STEPPE ORIGINS AND LEGITIMIZED THEIR CLAIMS TO RULE . . . "

—John Vollmer, *Ruling from the Dragon Throne*

WHEN THE MANCHU invaded China in 1644, they were not unfamiliar with the style of dress worn by the Chinese imperial family and court officials. Ming "dragon" robes had been received as tribute gifts since the early sixteenth century, however, their traditional full cut did not suit the Manchu modes of living or thinking. These nomadic horsemen from the north needed garments that conformed to a life of riding, herding, and hunting. The robe we recognize today as Manchu evolved from the natural outline of animal skins, the earliest form of clothing. The curved shape of the side-closing flap follows the contour of two pelts overlapping, providing additional warmth and protection for the wearer's torso. Much more fitted than a voluminous

★ (Opposite) Man's brocade robe with distinctive Manchu horsehoof cuffs (folded back in this example), and front and back slits, circa 1900. (Private collection, Chris Roche Photography.)

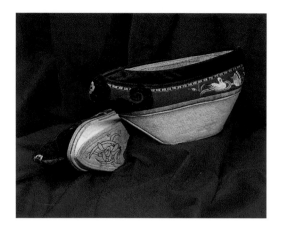

★ Embroidered silk with velvet appliqué Manchu platform shoes, circa 1898. Length 9 inches. (Author's collection, Larry Kunkel Photography.)

Ming robe, the Manchu coat is collarless and has tapered sleeves to keep out the wind, and distinctive crescent-shaped cuffs called *ma-ti hsiu* or "horse-hoof" cuffs, originally designed to protect a rider's hands from the elements. These long-skirted robes had a slit on each side for ease in mounting and dismounting as well as slits front and back to accommodate the pommel and cantle of a saddle. Around the waist a tight belt was worn from which hung necessities such as knives, purses, and other items.

Manchu women wore robes generally similar to those of the men. One difference, however, was the position of the slits, which, instead of being at the front and back to facilitate a life on horseback, appeared only on the two sides. (Side slits were to reappear later as an important element of modernization of dress in the 1920s and 1930s.) Court robes worn by the Manchu empresses and imperial consorts were similar to those of their husbands, except for a preference toward wider sleeves and less exaggerated cuffs.

Han* Chinese women were already wearing certain items of clothing that had been influenced by the Manchu nomadic style. Two of these items were trousers and paired apron skirts worn for informal wear. The paired apron skirt was made of two equal lengths of cloth, generally silk. These were attached to a wide waistband of heavy linen or cotton. The skirt was pleated with a single straight panel, about ten inches wide, front and back. The lower section of these two panels frequently featured elaborately embroidered scenes.

Another important distinction between Han and Manchu styles was the thousand-year-old practice among Han women of footbinding. Manchu

*A Chinese dynasty, 206 BC–220 AD, that gave its name to native Chinese peoples as distinguished from non-Chinese, such as Mongolian.

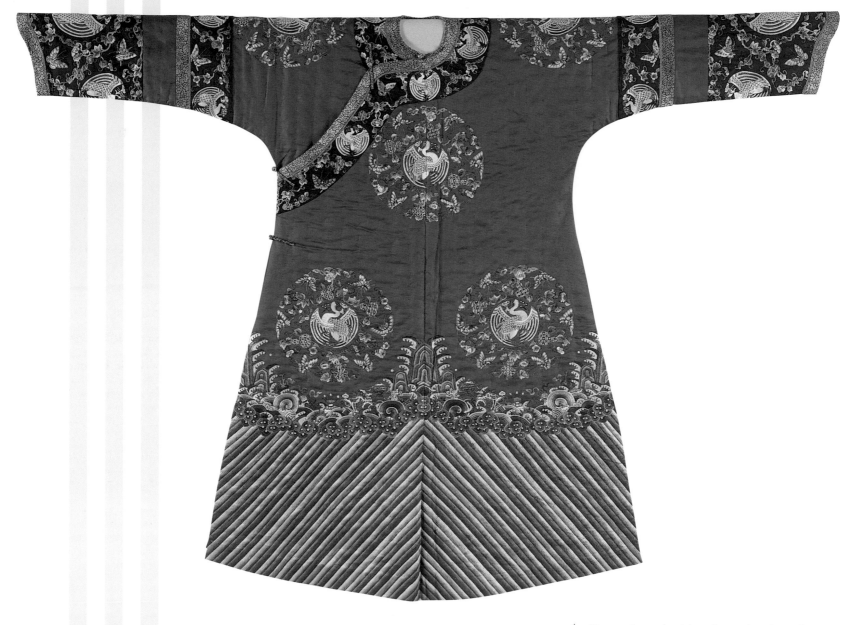

★ Woman's embroidered court robe, circa 1900. The cuffs are rounded, a modification still suggestive of the horsehoof cuff typical of a man's Manchu robe. (Author's collection, photograph by the author.)

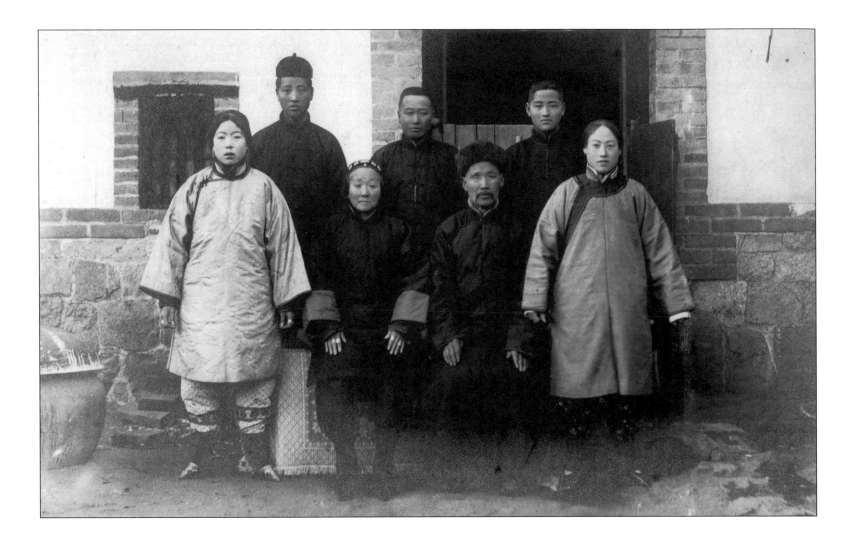

★ Han family portrait, circa 1900. Long voluminous jackets are paired with trousers for both women and men. The women's sleeves are wide and feet are bound.

women were forbidden by the emperor to bind their feet following the Manchu invasion of 1644. Many Han women continued to bind until 1949.

Following the Manchu conquest, it was decreed that anyone who joined the government had to adopt the Manchu style of dress to prevent discrimination between the conquerors and the conquered. These robes were a modification of the Manchu coat. By 1759 all clothing became regulated when the Emperor Qianlong issued an edict on dress published in the Collected Acts of the Dynasty. From this date on there would be no question about what could

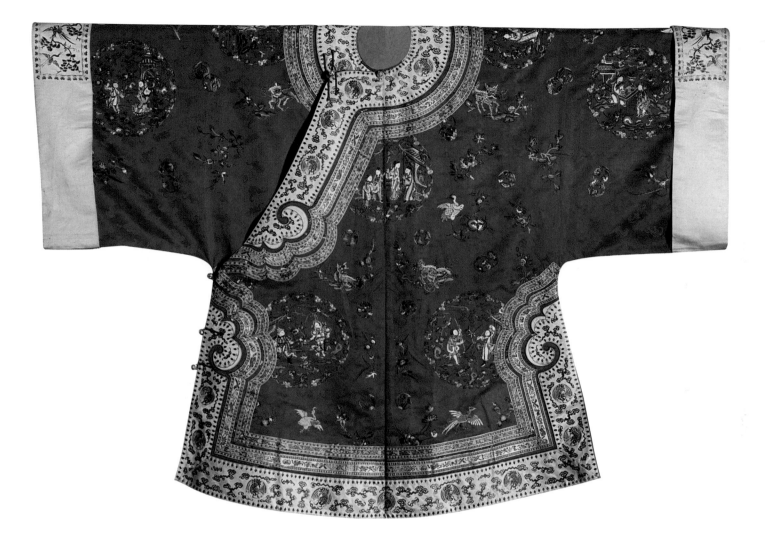

be worn on a specific occasion by a particular group of citizens. Color, for instance, was strictly regulated. Yellow was worn only by the emperor and empress. Robes worn by the emperor for religious ceremonies was also proscribed. Red was worn in spring when he made a sacrifice at the Altar of the Sun, while blue was required when he prayed at the Altar of Heaven. Orange, another imperial color, was worn by the emperor, empress, the crown prince and his consort. Brown was limited to first- through fourth-rank princes and the consorts of first- and second-rank princes.

★ Wide sleeves on this embroidered silk Han-style jacket, circa 1900, had a practical application for mothers who could utilize the extra width by easing an infant inside the jacket for discreet nursing. (Author's collection, photograph by the author.)

Furs also came under the new rules. Traditionally, fur lined the inside of a robe, leading to the name *duan zhao*, or "inside-out coat." These robes opened straight up the front like a *pu fu* (outer surcoat on which badges denoting the civil or military rank of the wearer was attached front and back). The emperor had two official fur options, sable for late autumn and early spring, and black fox for winter. The right to wear sable could be awarded to a lesser nobleman by the emperor as a special honor. The heir apparent was the only other man who could wear black fox. Blue fox was allotted to other imperial princes. Mink was worn by first- through third-ranking officials. A lynx robe lined in mink could be worn by a first-class imperial guardsman, while lower-ranking imperial guards wore leopard. This rigorous dress code was followed closely throughout China until the death of the last Empress Dowager Cixi in 1908.

The end of the Qing dynasty in 1911 marked the beginning of the end for traditional Han and Manchu clothing styles for women and the gradual transition to a more modern silhouette. Until this time, a woman was required to dress very modestly in garments that did not reveal her body shape. The typically loose-fitting trousers and wide-sleeved jackets did this quite well. So when the Han women in Shanghai narrowed their trousers and sleeves, it was a revolution in the making. In addition, jackets were shortened and collars were raised to balance the new slimmer proportions. At certain periods during the 1920s and 1930s, collars went so high they sometimes touched the wearer's ears. Also, during this period Manchu women began to narrow their sleeves and take in the width of their voluminous robes.

The causes for change were complex and varied. The establishment of the Republic in 1912 brought great change to all Chinese women. Prior to this period women had few options apart from marriage, confined and defined as

51

★ Manchu family portrait, circa 1900. Proportions are slimmer and the woman's feet are not bound.

they were by the tenets of Confucianism—even in cosmopolitan Shanghai. Women from wealthy families had spent their lives behind high family-compound walls. So when they took their first steps out into the modern world, it was a radical departure from an ancient patriarchal system.

In Shanghai women were more exposed to foreigners than elsewhere in China, so it is not surprising that fashions inspired by Western styles would originate in the city that was often referred to as the "Paris of the East." Respectable women, however, were not the innovators of such trends. They were followers. The courtesans and top prostitutes, who were in closer contact with Americans and Europeans, pioneered the new styles. These were the women seen publicly at the horse races, dog races, and other sporting events, at parties and cabarets—never alone—always escorted by the wealthy Chinese men who kept them. They were written about in magazines and newspapers and posed for the wildly popular calendar posters that spread the new looks in hair, shoes, clothing, and cosmetics. (This situation was certainly not unique to China. High style had already been established in Paris during the period prior to World War I [1890–1914] known as Belle Époque. Fashions that had previously been corseted and covered-up were loosened and liberated by women of questionable reputation, namely actresses and courtesans.)

And it was not only proximity to foreigners, but also the glamorous world they saw on movie screens and the glamorized lives of the stars they read about that made women eager to embrace what was new. Interestingly, Shanghai girls did not precisely replicate Western clothing. Instead, they interpreted and adapted the freedom of its fit and expression to their own needs and aesthetic. For inspiration of cut, they looked to the Chinese man's informal robe, the *changsam*, or what we think of as the "scholar's" robe, which follows the

basic cut of the Ming dragon robe discussed earlier. The changsam was a simple robe, without any ornamentation, worn by an official under his surcoat that bore his badge of rank. The scholar's robe was floor length, buttoned at the side with a small standup collar, and generally was plain dark blue silk or pale blue cotton. This was the true prototype for the ladies' *qi pao* or *cheongsam*. "Qi Pao" is the Manchu name for the type of dress that became popular in China in the 1920s. "Qi" comes from the character for "banner" and refers to the banner-carrying Manchu warriors who invaded China in 1644, and "pao" translates to one-piece dress or robe. ("Cheongsam," another popular name for this garment, is its Cantonese translation.)

★ Liu Hao-Sun's mother (seated, center, holding an infant) celebrates her 60th birthday surrounded by her family, Shanghai, 1933. The men, and one little boy seated in front, all wear the long scholar's robe, or changsam, topped by a short black jacket with a central vent, or ma gua. The cheongsam, worn by the women, were derived from the changsam. (Collection of Edith Liu.)

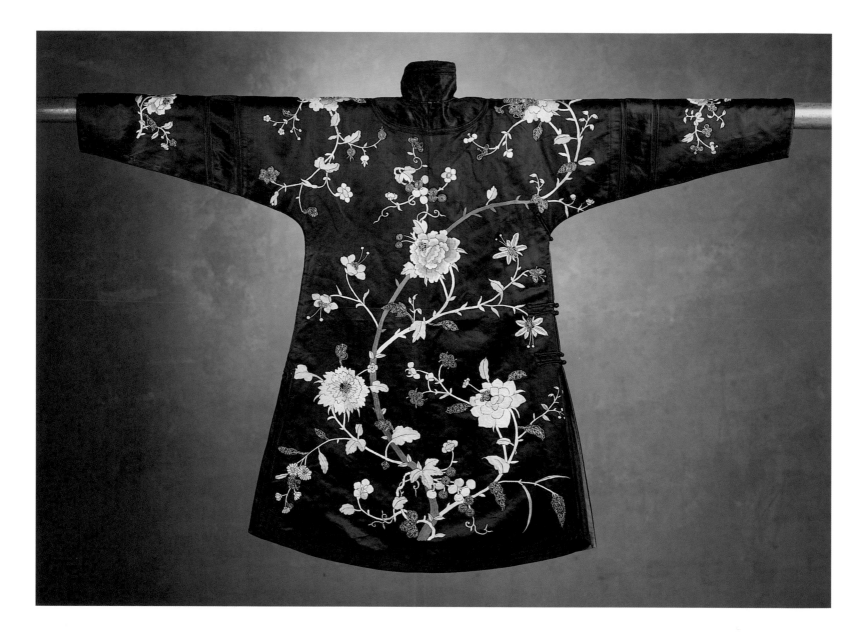

★ Richly embroidered robe with tapered sleeves shows the earliest signs of modification, circa 1910. (Author's collection, Chris Roche Photography.)

Fashion doesn't change overnight, but evolves slowly from a basic starting point. The evolution of the cheongsam started through the width of the robe, in other words, modernization meant narrowing. Narrowing began slowly and conservatively and climaxed in the clingy, form-fitting dresses of the 1930s, influenced by the bias-cut gowns of popular Hollywood movie stars.

★ The robe has become a qi pao. The form is more fitted, although not yet clingy. The side slits, short hemline, high collar, and three-quarter length sleeves indicate the early 1920s. (Author's collection, Chris Roche Photography.)

Wide sleeves narrowed, and also got shorter, as part of the continuing modernization of the robe. Because the traditional Manchu robes featured horsehoof cuffs that covered the hand, the innovative elbow-length sleeves on the new dresses must have been puzzling to elderly Chinese. Sleeves continued to rise, until ultimately they stopped at the shoulder seam. There they dis-

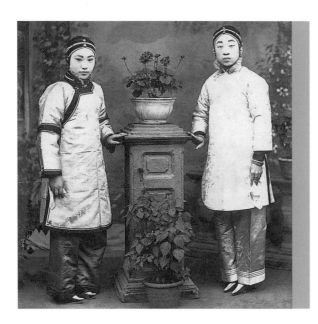

★ Stylish Shanghai girls, circa 1920, with bound feet.

appeared altogether, leaving us with the sleeveless dress we know today as the qi pao, or cheongsam.

As the width of the dress narrowed, the length decreased too. Skirts went up in the 1920s, and then later went down again in the 1930s, just as they did in the United States and Europe. As dresses grew more and more fitted to the body, mobility became a concern. Out of this evolved the side slits to enable walking, undoubtedly influenced by the original side-slitted Manchu robes.

Cheongsam hemlines began below the ankle, with the slits only a few inches high, barely exposing the new high-heeled Western-style pumps made from leather and other materials. Then, once again, the movies proved an influence on Shanghai style. In Hollywood actresses were exposing a lot more than their shoes. So in Shanghai, while hemlines stayed the same for a period of time, slits started to rise.

And the newly visible legs were flattered by Western-style shoes. All young women wanted this new look. But tiny bound feet encased in little slippers, for centuries demanded by generations of Han families, looked ridiculously outdated with the sleek, body-conscious cheongsam. Young women who were already burdened with bound feet had to find shoes that at least simulated the new Western styles.

In the early years of the Republic (1912–1949), the fashionable women of Shanghai wore flat embroidered silk shoes, if their feet were not bound. However, the new high-heeled styles were in huge demand by the early 1920s. Japanese shoemaker Mikawa did a brisk business in handmade Western-style pumps from his store in the Japanese Hong Kew area of the city. When Hollywood star Mary Pickford visited Shanghai with her husband Douglas Fairbanks in the 1920s, she purchased thirty pairs of Mikawa's handmade shoes.

One item that stayed the same as it transitioned from the traditional robe to the new qi pao was the knotted fabric button. Knotting is an ancient craft in China and falls into two categories, decorative and utilitarian. Evidence of early knotting for decorative purposes has been found on ancient bronzes dating back to the Warring States Period (475–221 BC), while rudimentary forms of buttons for closure date back to the Liu Song Dynasty (420–479 AD). According to Hsia-sheng Chen in *The Art of Knotting:* "The actual 'button knot' may be the Manchu contribution to the long tradition of Chinese knotting. This knot, which is still used on Chinese-style clothing, is first identifiable on a Qing dynasty (1644–1912) dragon robe."

The principle for knotted buttons has not changed from their earlier form. They were, and still are, made of corded fabric, usually silk, that is knotted into balls and attached to the fabric where closure is needed, then caught by loops of the same cording for fastening. The buttons and loops on cheongsam were either made with same material as the dress or contrasting colors were incorporated, thus creating a linear design. The corded fabric surrounding the button was often worked into interesting decorative shapes: abstract or realistic flowers, symbols, birds, fish, or butterflies, as examples. Imagination knew no limits in creating this type of trim. The closures and decorative work were called *huaniu.* In English, such knotted button closures are called "frogs."

Although intrigued with Western styles and fabrics, Chinese women never switched to wood, shell or metal buttons. However, as the twentieth century advanced, metal snaps, hooks and eyes, and ultimately metal zippers began to appear on even the finest cheongsam. The zipper, originally invented by Whitcomb Judson for use on men's boots, got to China in the late 1920s. Shanghai girls took a great fancy to it, using it to close the their qi pao, even

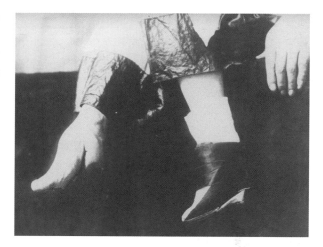

★ A woman's foot after a lifetime of binding.

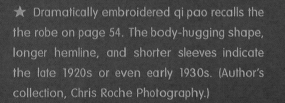 ★ Dramatically embroidered qi pao recalls the the robe on page 54. The body-hugging shape, longer hemline, and shorter sleeves indicate the late 1920s or even early 1930s. (Author's collection, Chris Roche Photography.)

★ Pigskin shoe with a wooden Western-style heel and elastic front panel, one of a pair custom-made to accommodate the bound feet of a fashion-conscious Shanghai girl who wished to appear modern, circa 1930. Length 3 3/4 inches. (Author's collection, Larry Kunkel Photography.)

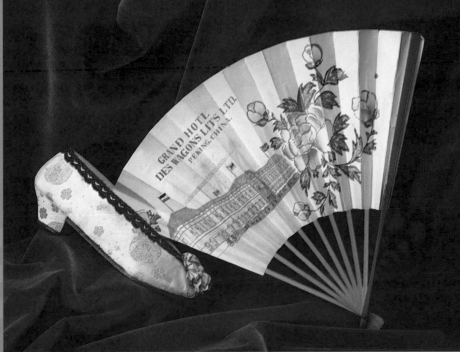

★ Silk damask Western-style pump made in Shanghai for a woman with bound feet to approximate a European dancing slipper, circa 1930. Length 6 inches. (Author's collection, Larry Kunkel Photography.)

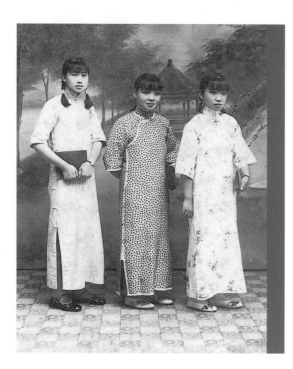

★ As the qi pao becomes more and more fitted, the sleeves become shorter and shorter, and fabrics become bolder and bolder.

on sheer chiffon gowns where it looked heavy and clumsy and all wrong. But the new zippers shouted "Western" and "modern" and these were the selling points for stylish young Shanghai girls.

Traditional Chinese trimmings included edgings of flat ribbon, braid, and piping along collars, cuffs, and hems of robes. But as time went on, these gave way to romantic ruffles, lace, feathers, flowers, and even fur. Shanghai girls also coveted imported fabrics. Appreciation for the gorgeous Chinese brocades and embroidered silks of the past was replaced by whole-hearted enthusiasm for the new imported synthetic fabrics. No matter how gaudy and unattractive the prints and color combinations may appear to our sensibilities today, they were all the rage among Shanghai girls.

Eventually, faces turned Western, too. Powder, rouge, and lip color had been used in China since the early dynasties. Eyebrows were shaved and drawn in with a charcoal pencil, sometimes called a "willow pencil." And elaborate face painting has always been a major component in Chinese classical opera. By the 1920s, Hollywood films and movie magazines were influencing women's cosmetics as well as their clothing. But, as with clothing, Shanghai girls tended to incorporate the old with the new to achieve a look that was uniquely their own way. For instance, many continued to use the thick chalky white rice powder on their faces and the willow pencil to shape their eyebrows. Some stained their lips with berry juice or by wetting scarlet paper and pressing it to their mouths. Red balsam blossom juice was still a favorite for coloring fingernails. However, for others the products made in America and France they saw advertized in foreign magazines were their cosmetics of choice.

Even hairstyles went through a dramatic evolution. Shanghainese girls were quick to bob their lovely straight hair, which they converted to masses of

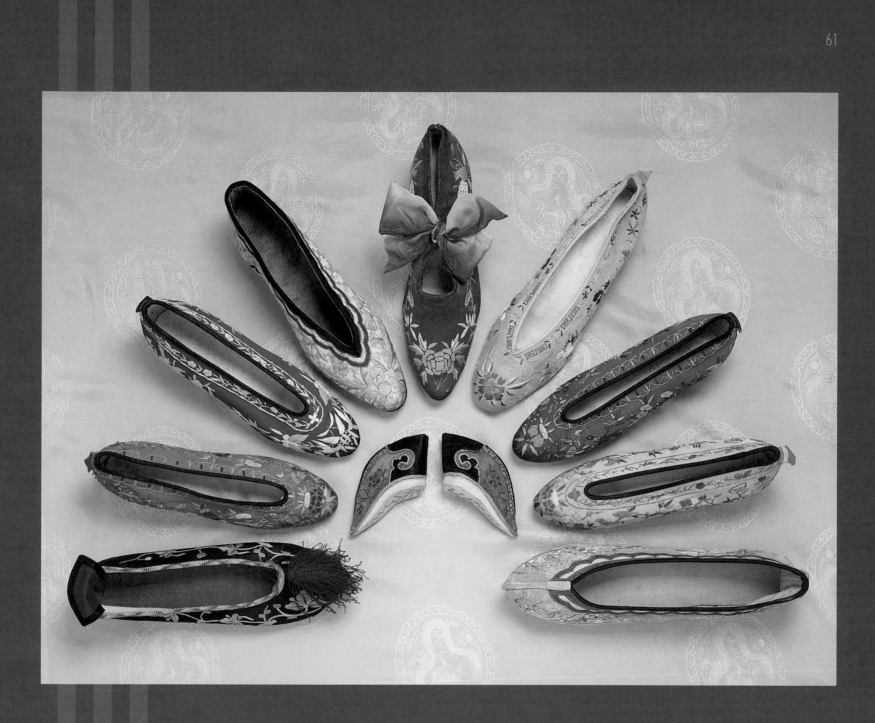

★ A pair of tiny silk embroidered and appliquéd lotus slippers, length 3½ inches (center), circa 1900, flanked by a collection of embroidered silk pumps, circa 1920. (Author's collection, Chris Roche Photography.)

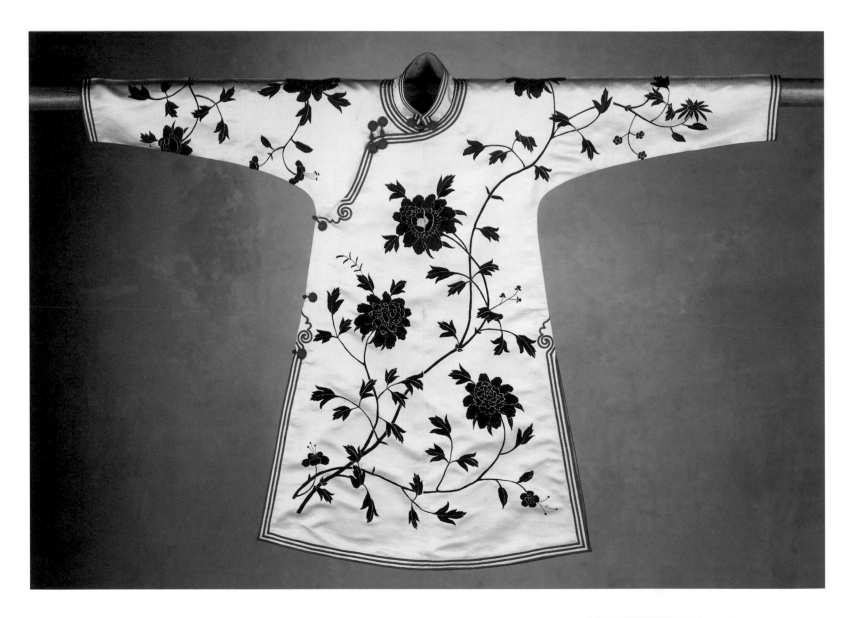

★ Embroidered silk robe employs crisp contrasting piping to delineate the knotted button and loop fastenings at the shoulder, side slits, and collar, circa 1920. (Author's collection, Chris Roche Photography.)

★ Detail of the elaborate, blossom-shaped hua-niu that echoes the floral embroidery on the robe.

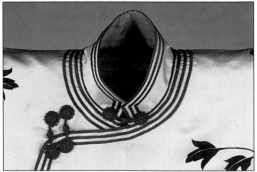

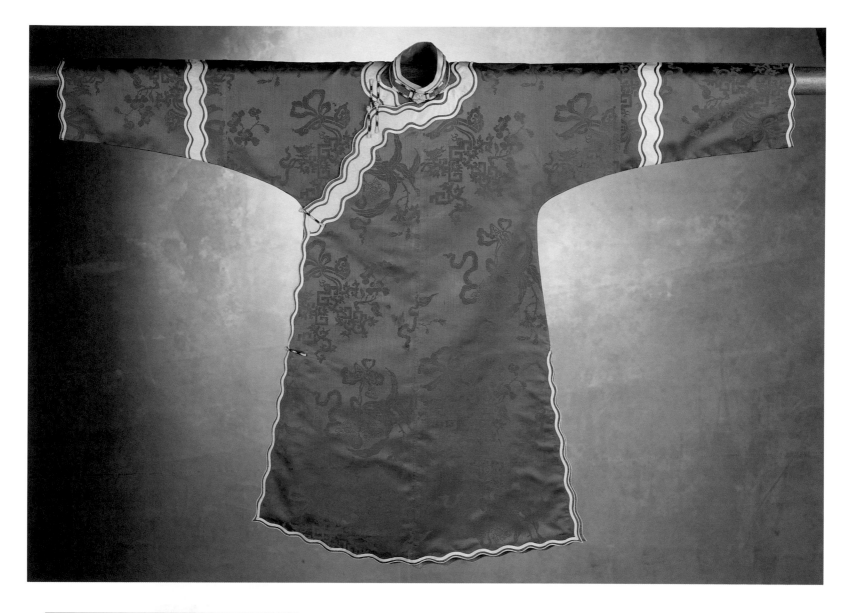

★ Damask silk robe with contrasting appliqué boldly highlights the garment's construction and echoes the serpentine pattern in the fabric, circa 1920. (Author's collection, Chris Roche Photography.)

★ Detail showing another form of the knotted button and loop closure.

★ This silk gauze qi pao, circa 1930, interestingly combines new style with old materials. The fabric is a lightweight, mesh-like silk traditionally used for making "summer" robes, that has been trimmed with 19th century embroidery similar to that found on the hem of the court robe shown on page 47. (Author's collection, Chris Roche Photography.)

waves and curls, the result of endless hours under the new permanent wave machines being imported into the city.

It is interesting to note that Shanghai's foreign residents did not, as a rule, embrace the cheongsam, but chose to stay with their own styles, seasonally updated thanks to imported magazines. The majority of Shanghailanders never adopted Chinese influence in dress or home decor.

★

In 1934, politics unexpectedly entered China's fashion arena when Mme. Chiang Kai-shek instituted the New Life Movement, with the intention of stimulating national pride and counteracting, what were considered in conservative circles, frivolous Western influences. This project was somewhat surprising since she herself had obtained her early education in the United States, first at Wesleyan College, and later at Wellesley. However, missionary friends had convinced Mme. Chiang that it was essential for her husband (who led the Chinese Nationalist forces from 1928 and thereafter, using various titles including president of China, exercised virtually uninterrupted power as leader of the Nationalist government until the Communists took over in 1949, and president of Taiwan 1950–1975) to instigate social welfare programs for the masses if he expected to receive aid from the West.

The New Life Movement was based on the four ancient, traditional Chinese virtues of country, service, honesty, and honor. The program included social skills, such as improving personal conduct and hygiene (no more spitting on the street, bathing once a week, washing hands three times a day, etc.). Rules also covered personal appearance for Chinese citizens, particularly modesty for women, and were enforced. Wearing lipstick, red nail polish or rouge, or a permanent wave, if caught, could result in the police stamping "Queer Clothing" in

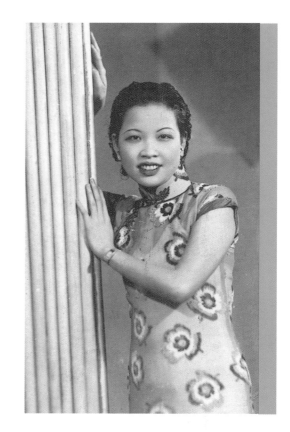

★ As the qi pao becomes more and more fitted, the sleeves become shorter and shorter, and fabrics become bolder and bolder.

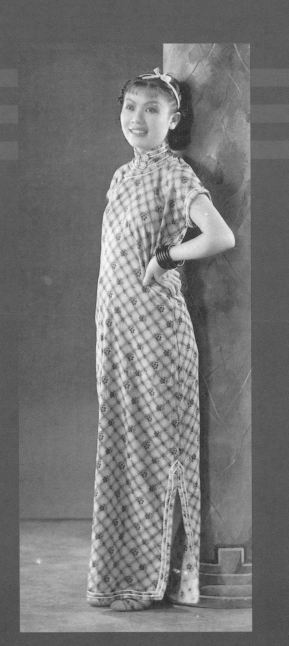

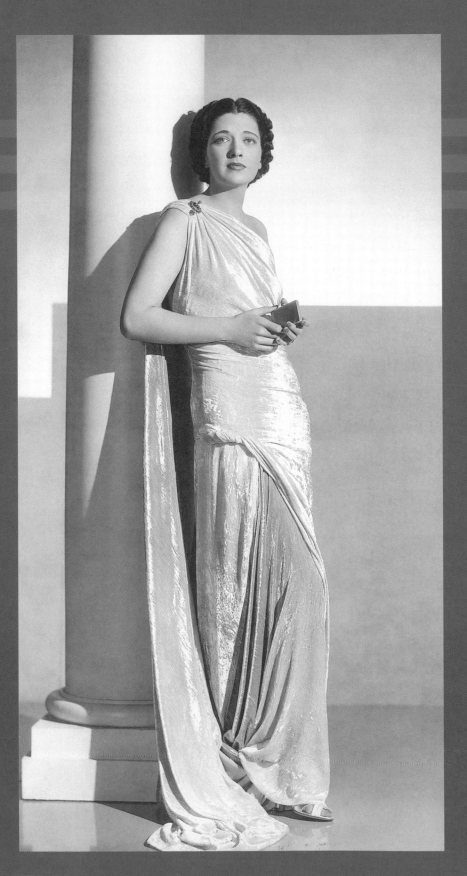

⭐ (Right) Hollywood film star Kay Francis, circa 1936. Her hair, makeup, and even her pose against the prop pillar, is imitated in studio portraits of young Shanghai movie actresses.

indelible red ink on the offender's skin. Skimpy bathing suits were unacceptable. Gowns were to be fashioned of Chinese fabrics with sleeves reaching to the elbow. Thus, the New Life Movement left its mark on the cheongsam for a time. In Shanghai, however, where the international concessions were beyond the reach of the New Life Movement, the fashion scene was little affected.

It should be noted that Mme. Chiang was one of the most powerful women in history. For many years Americans ranked her among the ten most popular and respected women on earth. Although time has revised this perspective, she is, nonetheless, a significant figure. She was, among other things, *the* fashion icon of China, and her permanent choice of attire was the qi pao. She never appeared in public in Western-style dresses, although she did wear high-heeled Western-style shoes.

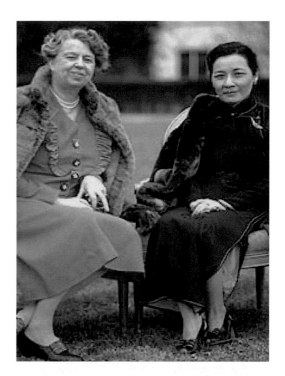

★ During her 1942 visit with President and Mrs. Franklin D. Roosevelt in Washington D.C., Madame Chiang Kai-shek managed to infuriate not only the White House staff with her imperious behavior, but the First Lady as well. However, being a perfect political wife, Eleanor Roosevelt manages a big, if forced, smile for this photograph.

Calendar Girls and the Qi Pao

"WHO WERE THE GIRLS? IT'S A GOOD QUESTION. OF COURSE SOME OF THEM WERE WELL-KNOWN MOVIE STARS OR FAMOUS ACTRESSES AND SINGERS. BUT THE REST ARE A MYSTERY.... SOMETIMES THE ARTIST MADE UP A FACE, OR STARTED WITH A PICTURE OF A HOLLYWOOD STAR, LIKE JEAN HARLOW OR JOAN CRAWFORD, AND MADE HER FACE LOOK A LITTLE MORE CHINESE."

—Vivienne Tam's interview with Margaret Huang, *China Chic*

CALENDAR POSTERS, so popular all over China, were called *yuefen-pai*, or "month boards." The earliest calendar posters were giveaways with the purchase of Shanghai lottery tickets. Later the companies that advertised their products on the posters gave them to customers at the beginning of each lunar New Year. In fact, two calendars were printed on each poster, to include solar and lunar dates. And the twenty-four solar signs were displayed as well. Once it was hung up on the wall at the beginning of the year, the calendar stayed up until the new one was distributed the following year. Consequently the company's name was displayed prominently in the recipient's home for the entire year. Good advertising indeed!

★ Calendar girl wears a Han-style jacket that has the newly narrowed sleeves and a very high collar with the traditional paired apron skirt and typical hair ornaments like those shown on page 56. This very early poster, printed in 1915, is the only known example that shows a model with bound feet encased in tiny lotus slippers. The artist was Yang Qinsheng.

69

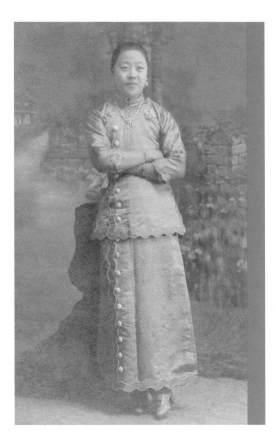

★ Young woman, circa 1918, in an interesting modification of a conventional Han-style jacket and skirt. The jacket has the traditional side closure but appears to be somewhat fitted through the waist. The collar is high and the sleeves are narrow. The skirt does not have the front and back panels of the paired apron style, rather the side closure continues from the jacket to the hem, creating the illusion of a single garment not unlike the qi pao. Her smartly buckled shoes are clearly Western with a substantial heel.

The actual product advertised, however, was frequently minimized by a much larger illustration of a pretty young woman that filled the major portion of the poster. The product or products were usually pictured quite small, possibly in rows, beneath or imbedded in the border surrounding the main illustration. The name "yuefenpai" first appears in 1876. At this time the Taohuawu art studio in Suzhou innovated the basic design that would be adapted throughout China by placing the products in the secondary position with the solar signs that bordered the central image. Eventually, poster printing would center in Shanghai, Canton, and Hong Kong.

Yuefenpai were made using the color lithography process invented by Alois Senefelder in Germany in 1796. More accurately, the process was accidentally discovered when Senefelder's mother asked him to write a laundry list for her. Having no paper handy, he wrote it on a freshly polished slab of locally quarried limestone he'd been using for etching practice. This led him to experiment further and he developed a method of marking the stone with a greasy composition of soap, wax, and lamp-black. He then washed the absorbent stone with water, which penetrated the surface on the unmarked areas of the stone. Following this, printing ink was applied to the stone's surface. It adhered to the greasy image but was repelled by the wet areas. And from this, a series of impressions on paper could be pulled.

Senefelder's method of preparing stones for hand printing is still the preferred method used by many artists in the twenty-first century. And the most desirable stone for the process is fine-grained limestone (calcium carbonate, $CaCO$) called Solnhofen limestone found in the Jura Mountains of Bavaria. Limestone found in other areas of the world is not the very fine quality that lithography requires. Multiple stones are used in the lithographic printing

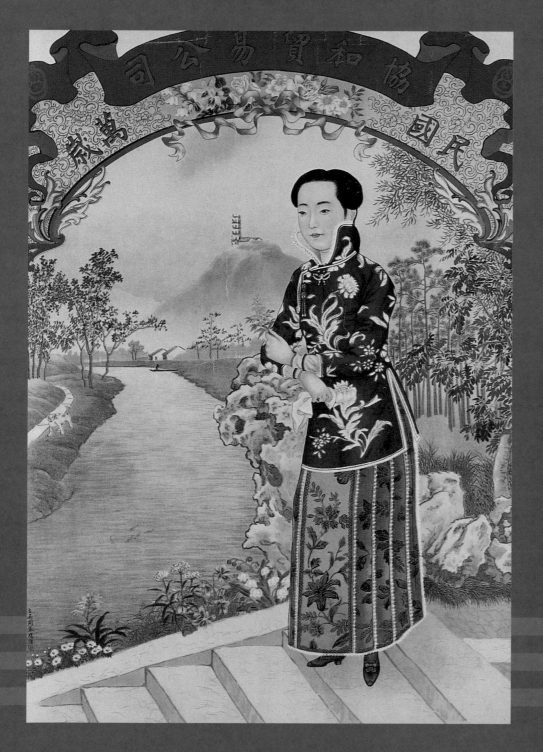

★ Calendar girl, circa 1915, wears a slim-sleeved, high-collared jacket with a paired apron skirt and, although her feet are small, they are not bound. She wears embroidered and be-ribboned Western-style shoes similar to those shown on page 61.

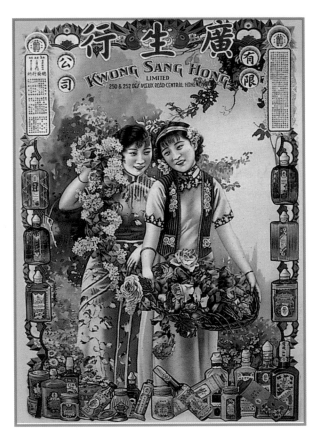

★ In addition to promoting a dizzying array of perfumes, powders, and pastes, these girls are also promoting short sleeves and short hair, circa 1925.

process, one stone for each color. The print paper goes through the press as many times as are needed for the number of stones being used. The tricky thing is to ensure that each print is lined up *exactly* as the artist has prepared each successive stone to fit. Only with precision accuracy can the color be in position with the overlaying colors merging correctly.

For early lithographs only one or two colors were used to tint the entire plate, creating a watercolor-like tone. Artists still used hand coloring over this background for details. As the artists and printers became more secure and more skilled, brighter and bolder colors were added, as well as overprinting with metallic inks in silver and gold. With the invention of steam-driven printing presses and wider availability of cheaper paper stock, the process became less laborious and more affordable. By the 1880s it was being utilized by magazines, and for advertising posters in the West.

In addition to printing, Shanghai, Canton, and Hong Kong enjoyed thriving economies with many other manufacturing and import/export ventures. This attracted lively competition among businesses, both foreign and Chinese, which in turn created a demand for competitive advertising. For example, as the market for Chinese smokers grew, the competition among cigarette companies fighting to gain control of it was fierce. The result was an enormous number of promotional calendar posters created for each company.

In Hong Kong during the peak period of popularity for calendar posters, one man, Kwan Wai-nung, gained a monopoly on both the design as well as the printing and was dubbed the King of the Calendar Poster. (One of the famous names among Chinese artists from the early nineteenth century was Kwan Kin-Hing, the great-grandfather of Kwan Wai-nung. Westerners know the elder Kwan as the artist Lamqua, whose paintings of Canton harbor are in

museums throughout the world. Lamqua is also remembered as the pupil of renowned English artist George Chinnery.)

Subject matter for the earliest Shanghai and Hong Kong posters was based on ancient legends and historical tales. Inevitably, the emphasis shifted from mythology to modernity as young women posed in ever-evolving fashions, from modified jackets and skirts to the sleek, chic qi pao. Eventually, courtesans and movie stars in the most up-to-date styles took over as models in Shanghai. Hong Kong posters had to follow suit and began to feature a modern young woman, or often a pair of women. The models were surrounded by a border in which the products being advertised appeared, along with the manufacturer's trademark, as well as the solar and lunar calendars. Quite frequently a catchy phrase or tagline about the product was included. But for female consumers, it wasn't so much the product as it was the young women in the posters—what they wore and how they wore it—that really mattered.

Hong Kong society was more conservative than swinging Shanghai in the 1920s and 1930s. So instead of courtesans and film stars, the early Hong Kong models were most frequently men posing as women. This wouldn't have been surprising to Chinese sensibilities. For centuries male actors were trained to play female roles in Chinese classical opera. So it would seem most natural for a man to don female attire and pose for an artist. As customs became more relaxed in Hong Kong, Kwan Wai-nung sought inspiration from fashion and movie magazines for his models and their poses. He even had his wives and other women in his household pose for posters, heavily clothed, of course.

Eventually, the posters were to become excellent chronicles of the period in which they were executed. Models wore the latest fashions and kept pace with popular style trends in makeup, hairstyles, and accessories such as handbags,

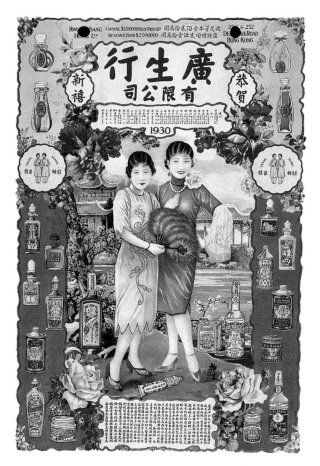

★ The same company (Kwong Sang Hong Ltd.) employs two girls to promote its product line, but their sleeker, more sophisticated fashions, hair, and accessories have been updated to 1930.

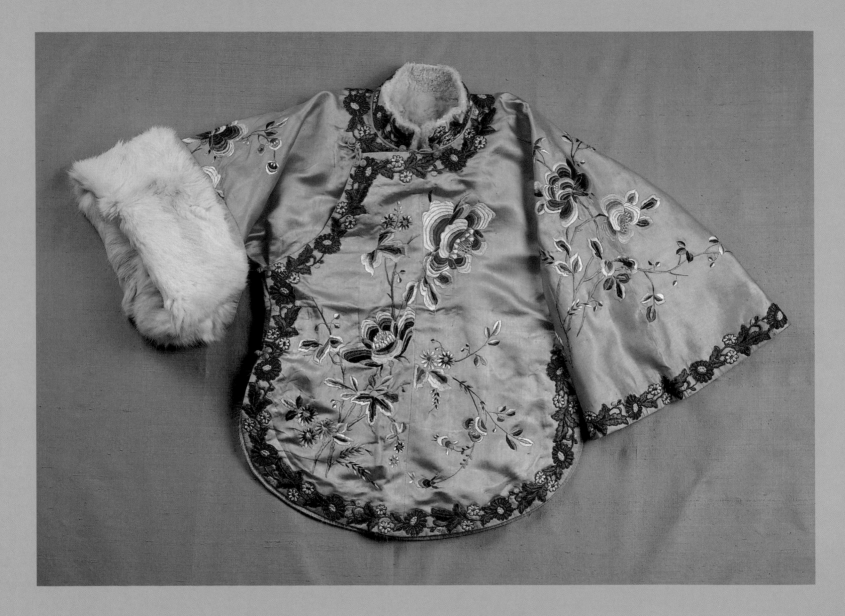

★ Embroidered silk jacket, lined in rabbit fur, circa 1915. (Author's collection, Chris Roche Photography.)

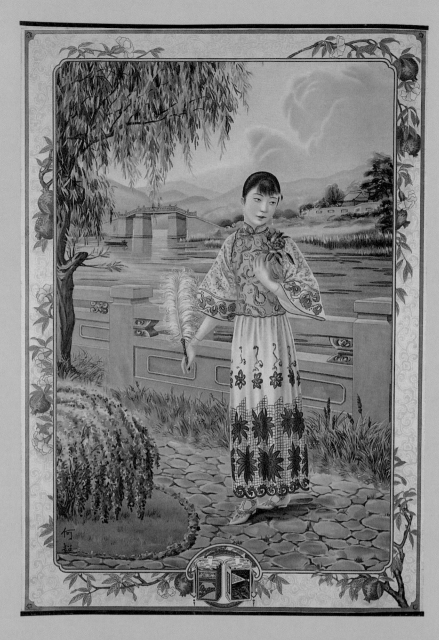

★ A pensive model in this cigarette poster strolls in a poetic garden set in a romantic landscape that recalls traditional Chinese landscape painting. However, her costume is anything but traditional and owes much to Hollywood publicity stills appearing in movie magazines of the day. She wears a short jacket-vest that reveals the waist with a sweeping gathered skirt, so different from the straight-cut, stiffly pleated paired apron skirt. Her dreamy, slightly melancholy demeanor, her shoes, and even the feathered fan in her right hand resemble the expression, shoes, and feathered hat in the Norma Talmadge photo, circa 1922. (Author's collection, Chris Roche Photography.)

★ Hollywood film star Norma Talmadge who, with her sister Constance, was a staple of the silent screen. In this publicity still, she wears a high-waisted afternoon dress designed by Peggy Hoyt, typical of the early 1920s.

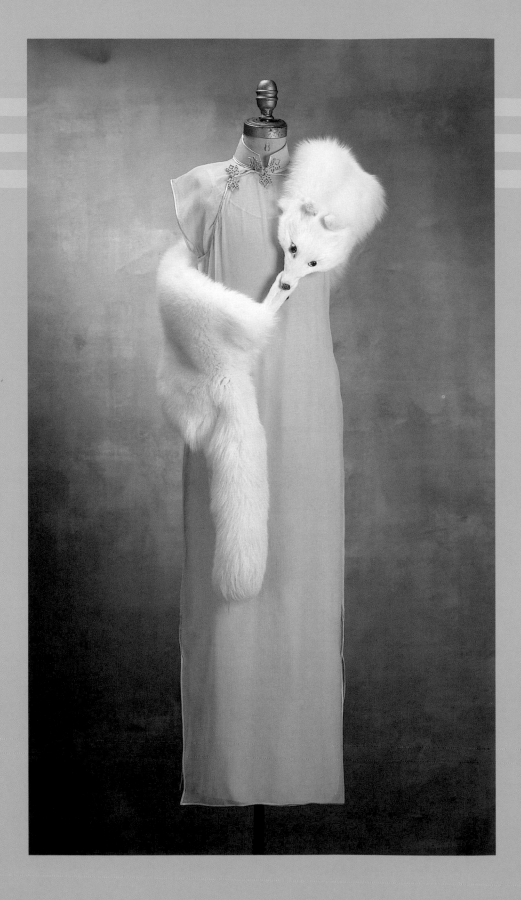

★ Silk chiffon qi pao with white fox stole, circa 1930. (Author's collection, Chris Roche Photography.

jewelry, furs—even pets! Women watched them closely for new styles, new fabrics, new trimmings, new cuts and colors. And when a model was depicted in a domestic interior scene, the furnishings and household accessories were also completely *au courant*.

Wealthy Chinese could afford to acquire what they saw on the poster. The slightly less affluent, but well-to-do could aspire to what they saw. The working classes could adapt what they saw to what they had. And the poor could dream. This is why the calendar posters became so critical to the changing face of fashion, literally as well as figuratively, in Shanghai, and later all China. Young, and not so young, women saw the stylish models portrayed on the posters and copied them, as best they could. These poster girls, along with Chinese and Hollywood screen stars, led Chinese fashion from centuries of traditional wide-sleeved jackets, wide-legged trousers, and voluminous robes to the sleek and unique, cutting-edge qi pao.

Once it was established, the qi pao would remain the favored garment for Shanghai girls, and women, until 1949. When history turned again and everyone—male, female, young and old—dressed in the same dull blue or khaki cotton loose-fitting trousers and front-buttoning jackets known as "Mao Suits." It wasn't until the end of the twentieth century that individuality was, once again, expressed through fashion and, once again, emerged in Shanghai. Today, the cheongsam of the 1930s has captured the fancy of women all over the world. Designers from Dior to Saint Laurent to Lacroix, Valentino, Prada, and Galiano, Vivienne Tam, Amy Chan, and Shanghai Tang, look to Shanghai's past for inspiration and the girls of long ago who got all dressed up.

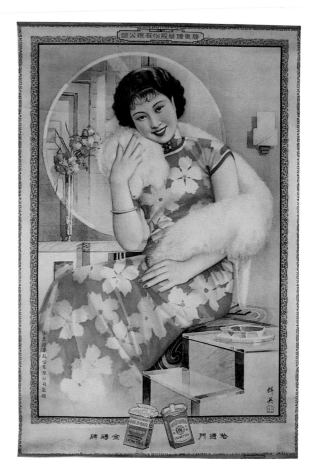

★ Another cigarette poster, circa 1930, but in this example, the setting is an up-to-the-minute Art Deco interior and the model wears a fully evolved qi pao with a white fox stole, all of which underscores the company's message of luxury and good taste. (Author's collection, Chris Roche Photography.)

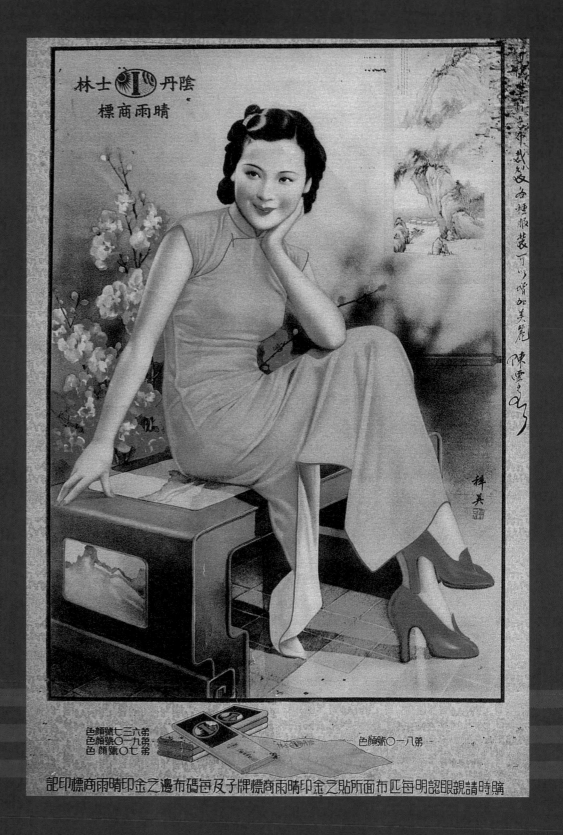

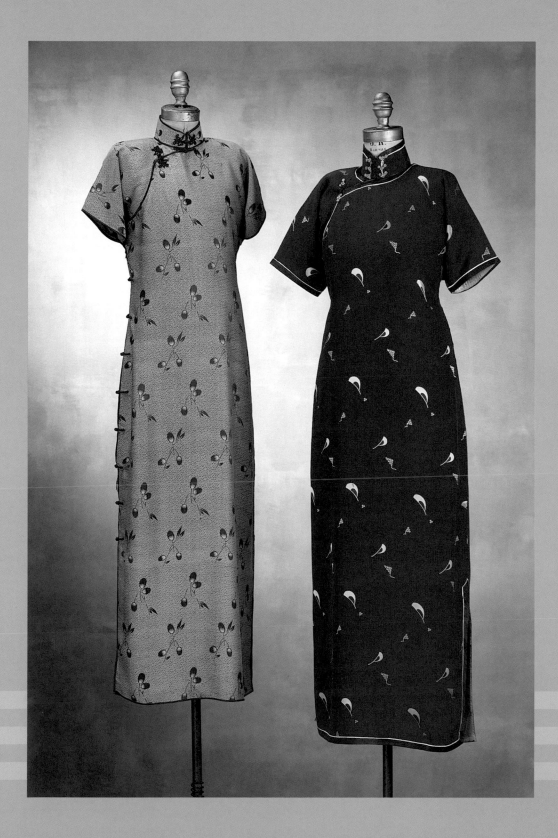

★ Two classic rayon qi pao, circa 1930. (Author's collection, Chris Roche Photography.)

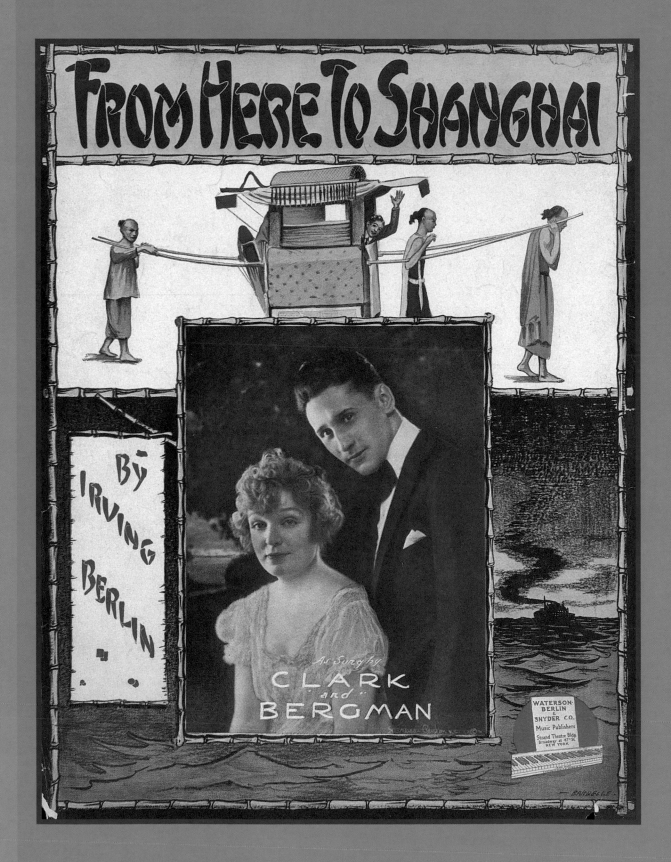

CHAPTER 5

Working Girls as Fashion Icons

"REVOLUTIONS MAY RISE AND BREAK, EXCHANGE MAY GO
UP OR DOWN, AND THE FAR EAST MAY TIE ITSELF INTO A
DOZEN DIPLOMATIC KNOTS, BUT THROUGHOUT IT ALL,
SHANGHAI CONTINUES TO WHIRL LIKE A DANCING DERVISH
UNDER THE PINK-SHADED LIGHTS OF ITS CROWDED CAFES."

—Elsie McCormick, *Audacious Angles on China*

SHANGHAI NIGHTLIFE in the 1930s, for those who could afford it, was like no place else on earth. Shanghai differed from other cosmopolitan cities like Paris, London, Budapest, Bucharest, New York, and San Francisco where nightlife was a way of life only for limited, special groups of people. In Shanghai, local Chinese, foreign residents, and tourists passing through were all out on the town after dark. Hundreds of cabarets and supper clubs sprang up throughout the 1920s and 1930s to keep them entertained.

Ballroom dancing and jazz music came to China late in the 1920s and became wildly popular in Shanghai. The first ballroom built just for the Chinese was in the Yipinxiang Hotel in the early 1920s. By the mid-1930s many

★ "From Here to Shanghai," a popular hit by Irving Berlin, circa 1917.

★ Taxi dancers (near right), circa 1920s.

★ Taxi dancers (far right), circa 1930s. (Steve Champion Collection.)

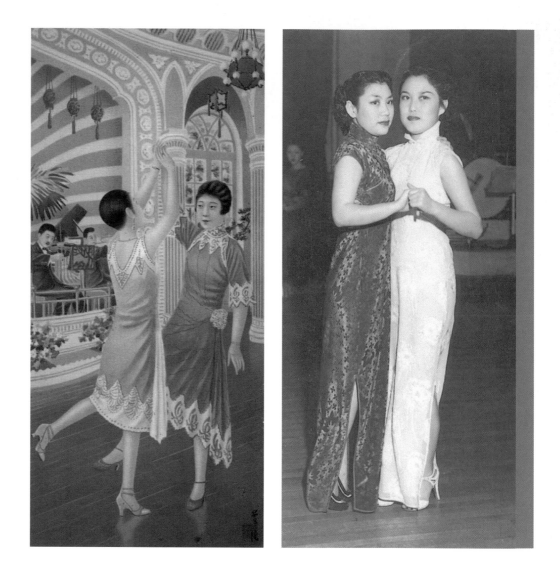

nightclubs were run and staffed by Chinese, with women working as waitresses, barmaids, performers, and dancing partners, or "taxi dancers," as they were commonly known. Although taxi dancers are often assumed to have been modern stand-ins for the Chinese courtesans of old, customers did not have the same expectations. A courtesan was required to be in constant attendance on her client for both social and sexual services, all for a mutually agreed upon price that ascended with the self-esteem of the courtesan. A taxi

WHO WERE THE WHITE RUSSIANS?

White Russian émigrés were largely responsible for some of hottest nightspots in town. Who were the so-called "White" Russians? They were former Russian nationals who had remained loyal to the Czar, during and after the revolution, and forced to flee their homeland or be killed. By the 1930s there were estimated to be at least 25,000 of them living in and around Shanghai.

Russian immigration brought classically trained musicians, ballet dancers, opera singers, and theatre actors to the city, usually arriving with little or no money, few possessions, but a lot of ambition. To earn a living they went to work as chorus dancers, taxi dancers, cabaret singers, and band musicians and became the backbone of Shanghai nightlife. It was a strange time for these displaced people. Some had left Russia as princes or dukes or counts, and became bus drivers, private chauffeurs, waiters, or doormen. A few managed to smuggle jewels or other treasures out with them that could be sold. But most were not so fortunate. Residents who used their services may have had no idea that their Russian cab driver might once have had his own liveried coachman and grooms to drive his splendid carriage.

For some refugees, their reduced circumstances brought them to a state of depression from which they never recovered. For others, it was a challenge they rose to with creativity and energy and a special aesthetic flair. And it wasn't only the men. Russian women were hired as performers, singing and dancing in the popular musical revues. The more ambitious among them went into business if they had money to invest or could find investors to help. Russian women ran some the best dress salons and most popular beauty shops in Shanghai. Of course, not everyone was destined to be an entrepreneur or impresario. Many female émigrés ended up at the cabarets as taxi dancers where they made good money in a safe environment. Others were forced to find employment with Japanese and Korean girls in the humbler dance halls that catered to sailors and working-class patrons. If a club did have Russian taxi dancers, it would be advertised outside, as these girls were particularly popular with young Chinese men. White Russian hostesses and dancing partners were the most sought after of any nationality as they were thought to be more sophisticated and better educated. They loved food and drink, had a sense of humor, and a gaiety about them in spite of their difficult circumstances. ★

★ Sing-song girls. (John L. Stoddard's Lectures.
Boston: Balch Brothers Co., 1897.)

dancer of the 1930s offered her customer a temporary diversion, as well as a good dancing partner for the price of the designated "tickets." Her prices descended as the quality of the club descended.

One stratum of entertainer that was exclusive to Chinese nightlife was the sing-song girl. ". . . Somewhere between the sixth and ninth pork courses the party was interrupted by the entry of a young lady who sparkled like Tiffany's Fifth Avenue window. She smiled apologetically, settled on the edge of a chair about two feet from the table . . . and went into silent contemplation. Nobody offered her anything to eat and just as you had about forgotten her existence, she fixed her eyes on the ceiling and broke suddenly into a series of yowls that would outdistance a Cat Show. After being startled into upsetting your shark's fins, you suddenly realized what had happened. You had just been formally introduced to the Shanghai sing-song girl." Thus did Elsie McCormick describe her in *Audacious Angles on China*. Sing-song girls were as ubiquitous to

men's parties as drink and food. After several songs the girl, or group of girls, were off to the next party on the evening's schedule. Unlike cabaret singers who performed the latest hits, a sing-song girl had only a dozen songs in her repertoire, all from ancient times. But a top sing-song girl was expected to keep pace with the latest fashions and styles of applying makeup.

While in some parts of China sing-song girls were expected to drink, socialize with, and possibly engage in other activities with their clients, Shanghai

★ Stylish high-priced prostitutes, circa 1910. Note their bound feet encased in tiny lotus slippers. These photographs would have been sent by the madam of their brothel to wealthy prospective customers.

★ Embroidered fur-edged duan zhao-style coat with narrow sleeves and high collar, circa 1920s. This example is spangled with metallic sequins indicating it was probably made for an actress or courtesan. (Author's collection, Chris Roche Photography.)

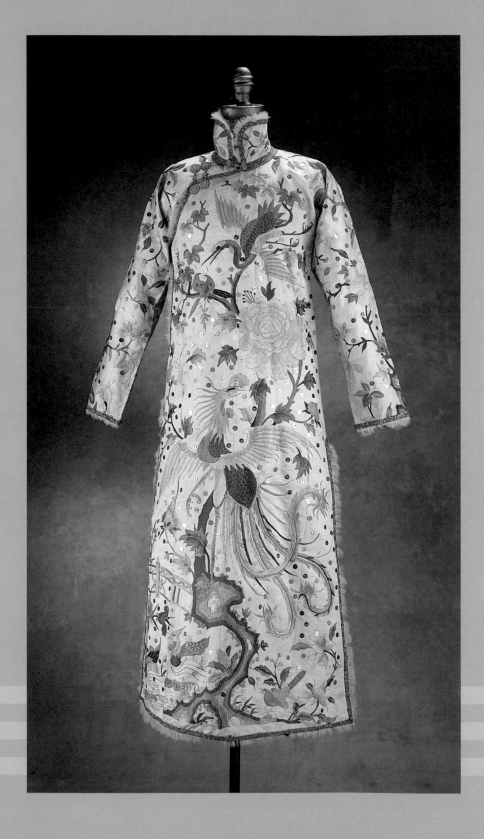

sing-song girls were not. This was left to the courtesans and prostitutes. Interestingly, courtesans had much higher social standing than sing-song girls. A very definite caste system reigned among working girls in China, with courtesans at the top of the scale. They catered to Shanghai's wealthiest Chinese businessmen and gangsters, and to foreigners. A courtesan was expected to hold her own in lively conversation. This required her to be knowledgeable on many subjects of interest to men, such as business, politics, and world affairs, in much the same way as the Japanese geisha. She strived to be an amusing, interested, and interesting companion.

Many lived in brothels that were spectacularly appointed and luxuriously furnished. French champagne was served to the customers and some of the best chefs in Shanghai prepared meals that were served all night if required. Some mistresses lived in a style that on the surface appeared to be more independent. They had their own apartments with servants, a stylish wardrobe and jewels, perhaps a car. A courtesan was expected to look fabulous—to set style trends rather than follow them. And the trends evolved from a variety of sources. To some extent they came from a courtesan's familiarity with foreigners—Americans and Europreans. But an even greater influence came from what she saw the screen stars wearing—both Chinese movie queens and Hollywood idols. Her expensive wardrobe would generally have been subsidized by money made either posing for the calendar posters and/or from liaisons with wealthy clients. Local scandal sheets, like the hugely popular Mosquito Journals, discussed these relationships in detail for their readers.

The next step down the scale from the top courtesans were prostitutes called *yao er*, the largest group of sex workers in Shanghai. The yao er didn't

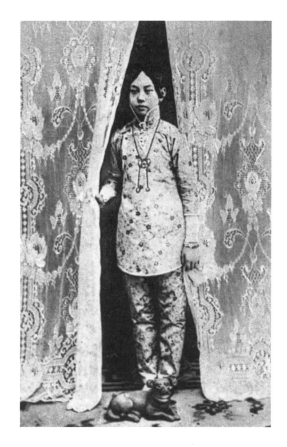

★ This Shanghai girl, circa 1920, wears a shorter length jacket that has narrow sleeves and an extremely high collar, paired with tapered trousers. It is probably no accident that the charming puppy at her feet makes it impossible to tell whether or not her feet are bound.

88

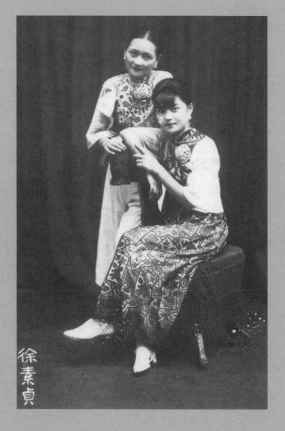

★ Shanghai girls (above) were often the models for the ever-popular calendar posters.

★ Calendar girls (right) promote Palmolive soap and cold cream, circa 1918.

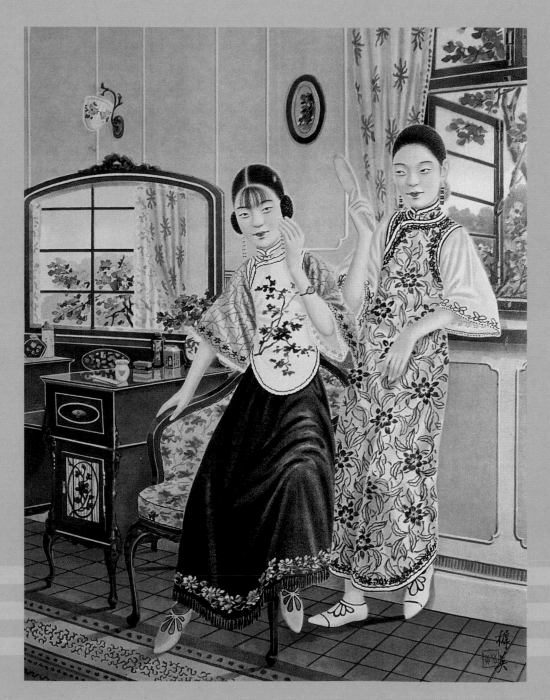

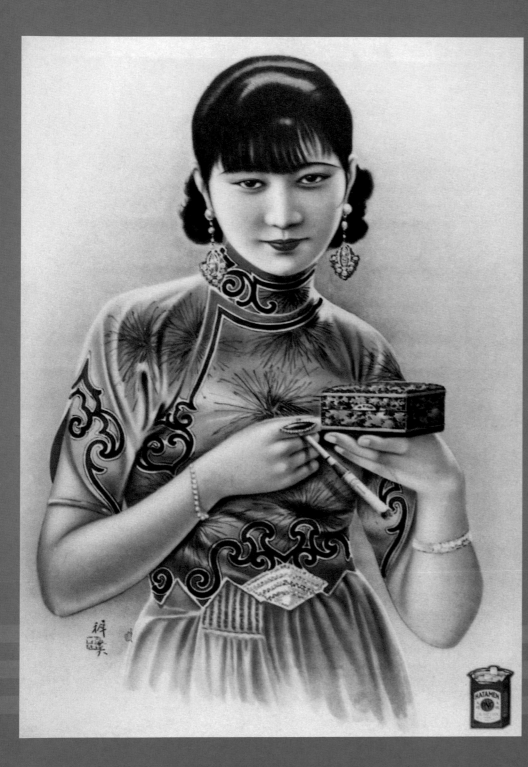

★ This chic Shanghai girl (above) could have been the model for the calendar poster (left), circa 1920s.

provide social amusements, but were available for sex. Russian women were the largest group of Europeans in this category.

In 1928 there were estimated to be 120,000 prostitutes working in Shanghai. In the French Concession on one short street called Seeking Happiness Lane (Hiu Le Li), at least 150 houses of prostitution could be found. And in 1935 it was estimated there were 100,000 licensed or unlicensed girls and women working as prostitutes. In fact, prostitution was so readily accepted in China that working girls of the Taoist faith had a god of their own, Lu Dong Bin, one of the Eight Immortals who lived at the end of the Tang Dynasty (618–907 AD). Public acknowledgement of prostitution was demonstrated in 1897 when a newspaper asked Shanghai residents to elect the four most beautiful prostitutes in the city. And over the next four decades many were elected as Shanghai beauty queens.

When photography first came to China, madams from the leading brothels were among the first to utilize it by having their top girls photographed for "calling cards" that were distributed in select restaurants and teahouses to wealthy patrons who might require their services. Along Seeking Happiness Lane, each house posted large strips of bright red paper on its front door that listed the names of their leading girls. Each house bore a memorably lyrical name, such as Colorful Clouds and Sweet Dew, printed on the lighted red globe hanging over its entrance.

One of the finest houses in Shanghai was run by a madam from San Francisco named Gracie Gale. Her house was located near the Bund on a street known for foreign brothels which locals referred to as "The Line." The décor was sumptuous with English antiques elegantly displayed. The Chinese chef Fan Lu prepared European haute cuisine in addition to local specialties. The

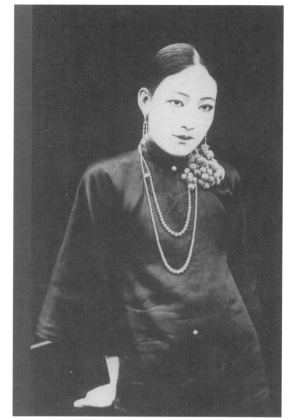

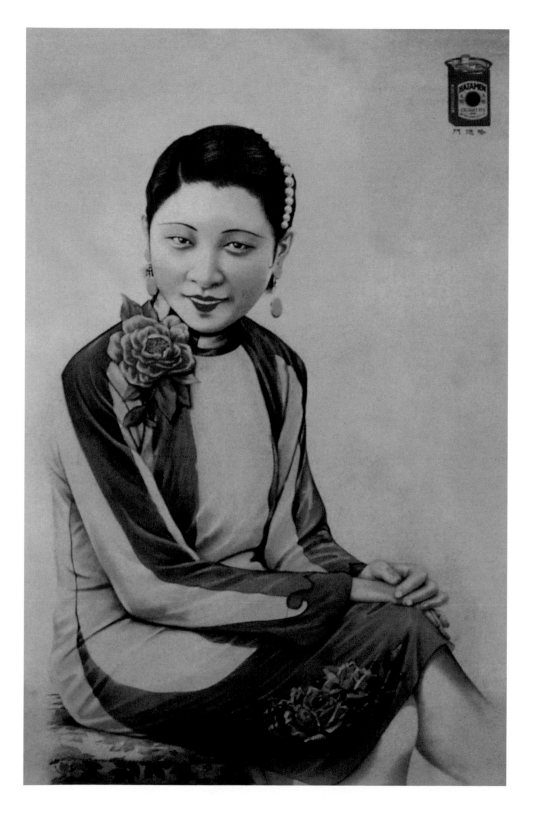

★ Courtesans were among the first to exploit photography (above).

★ Calendar girl (left).

★ Long tight sleeves, short sassy hemlines, and bright brocade fabrics made these qi pao perfect after dark. (Author's collection, Chris Roche Photography.)

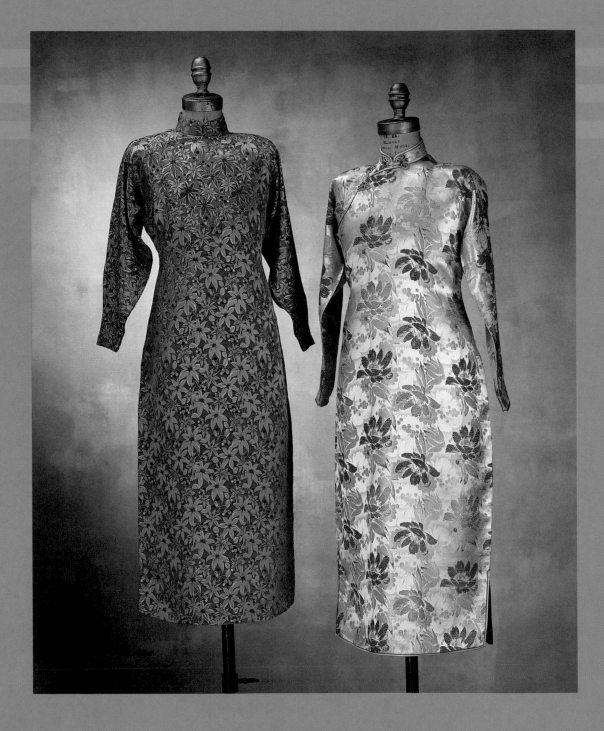

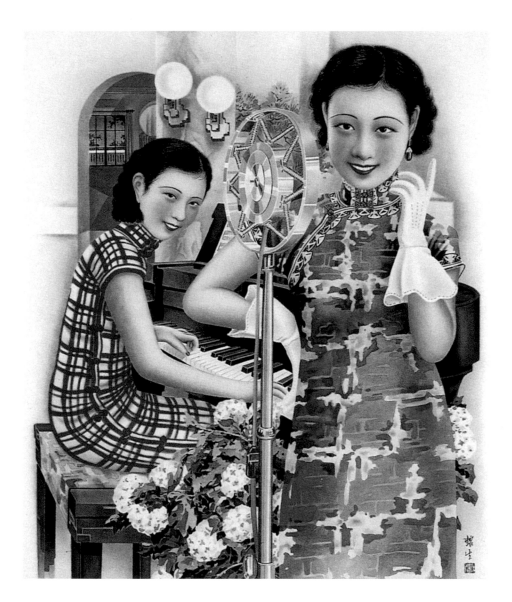

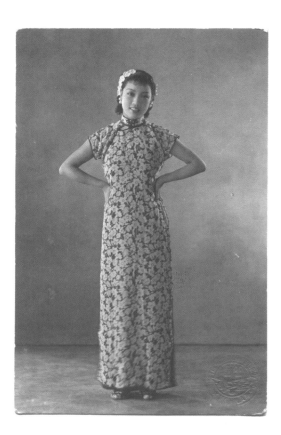

★ Bold patterns reflect the bold career choices that were opening up to Chinese women in the 1930s.

wines were the finest French. Gracie specialized in good-looking Americans and sent out engraved announcements to special customers whenever a new girl arrived. She imported their gowns from Paris and the United States. Gracie Gale had no Asian girls working for her, nor any Chinese clients. This was the general rule until the arrival of Russian refugees who were the first Caucasian women to accept Chinese men as customers. A successful house like Gracie's

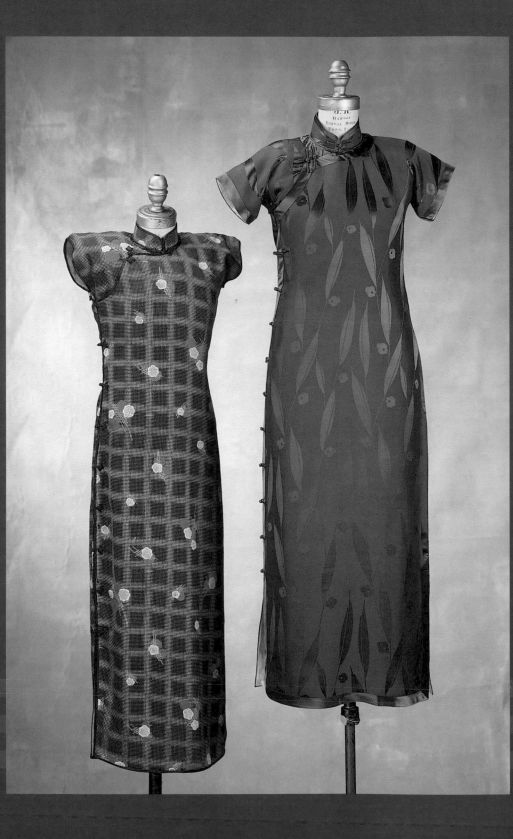

★ Ultra-sleek, ultra-chic qi pao, circa 1930s. (Author's collection, Chris Roche Photography.)

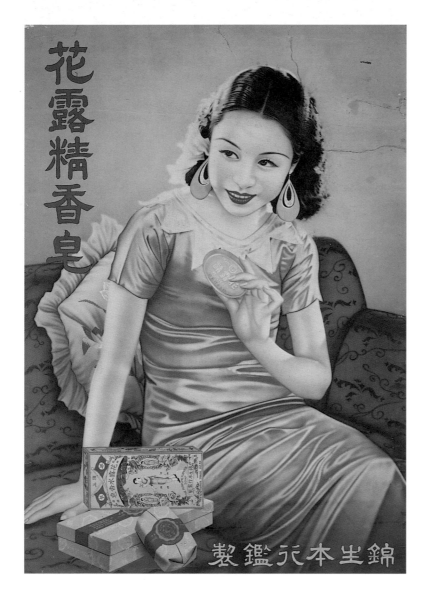

★ Actresses from the Shanghai film industry often modeled for the popular poster calendars. (Author's collection, Chris Roche Photography.)

was a source of income not only for the madam and her employees, but for the municipal government as well. The owners of both foreign and Chinese brothels paid very large licensing fees to the city.

From the expensive houses on The Line to the other end of the scale, we find the streetwalkers, called "pheasants," who could be found soliciting on the main streets of both the French Concession and the International Settlement. A pheasant's clientele were Chinese, foreign sailors in port, or poor foreign residents.

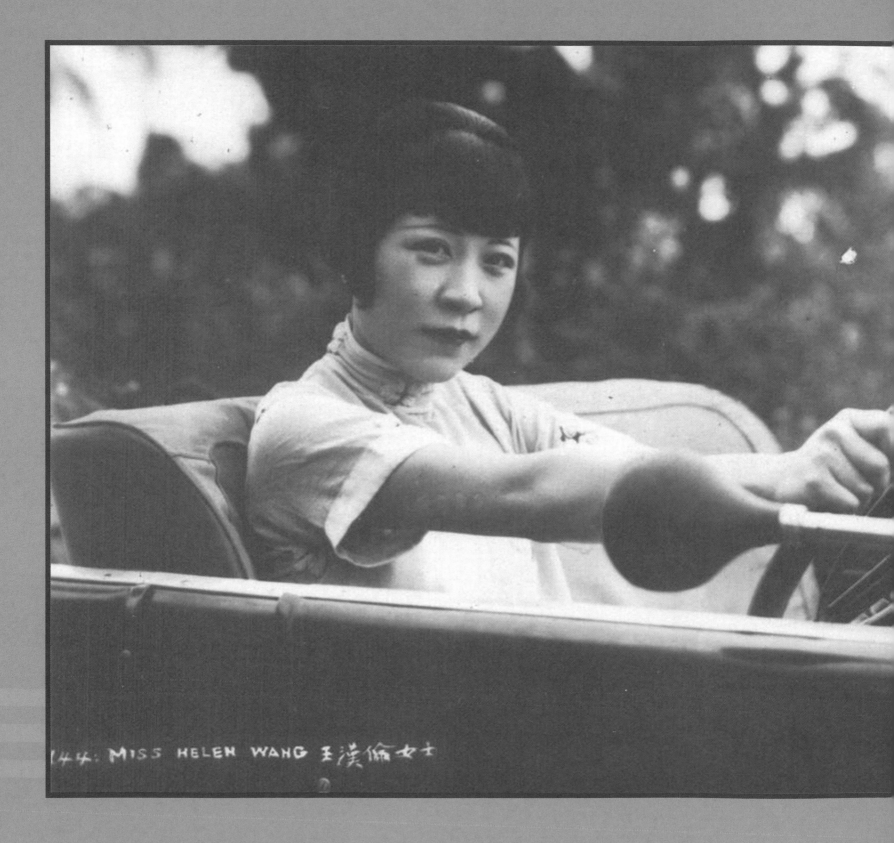

144: MISS HELEN WANG 王漢倫女士

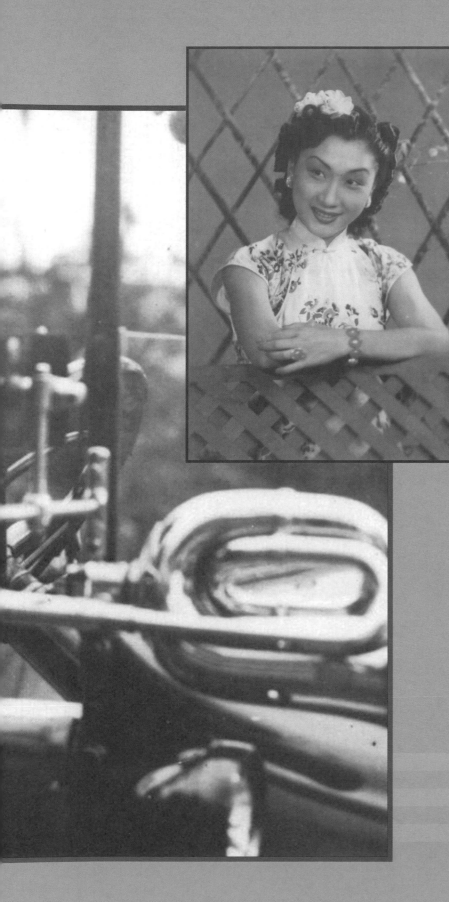

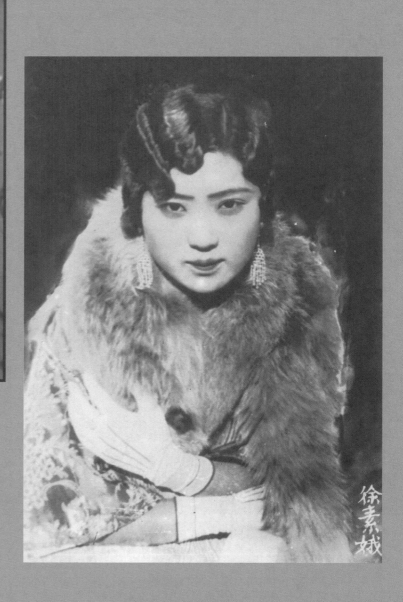

徐素娥

★ Actresses from the Shanghai film industry: (left) circa early 1930s; (center and above) circa late 1920s.

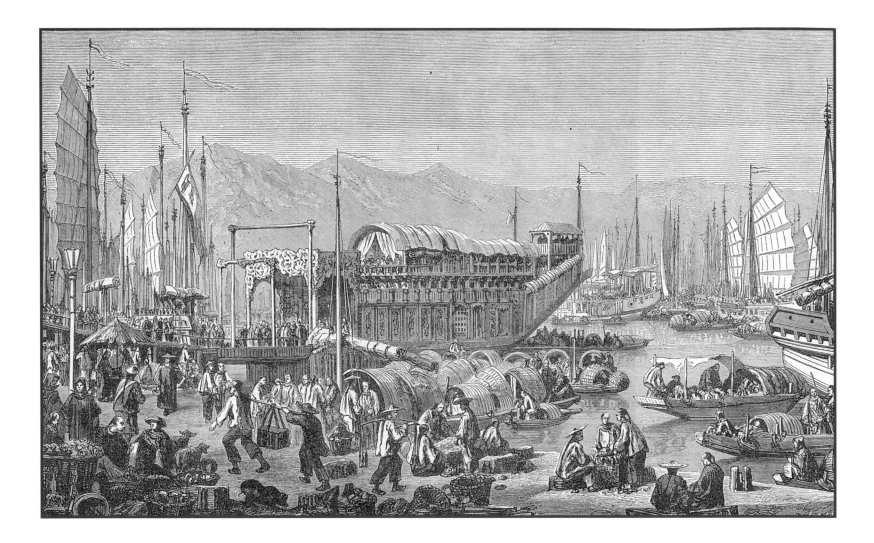

★ The colorful "Flower Boats," or floating broth-
els, moored along Suzhou Creek. Engraving,
19th century.

Even lower than Pheasants were the women who worked "Flower Smoke
Rooms." (A "smoke room" was a place where opium was available, and the
character for "flower" can also indicate a prostitute.) Flower Smoke Rooms
originally were located in the Native City, but eventually spread to the foreign
districts as well. Opium was easy to obtain in Shanghai and there were more
than 1,500 so-called opium dens in the city by the mid-1930s. Wealthy people
bought, or had their servants buy, their opium from opium shops for use at
home, while those of lesser means (or rich thrill-seekers), would frequent the

opium dens. Here they could purchase a prepared pipe filled with opium, ready to inhale.

Inside a Flower Smoke Room, or opium den as they have come to be known, there was a number of raised platforms. Opium smokers generally took their opium in a reclining position. In the better class of smoke rooms, platforms were covered with fine quilts and pillows. Frequently, two smokers would share a platform facing one another, a small oil lamp for heating the opium, and other smoking equipment between them on a tray. A small quantity of prepared opium (that has the appearance of dark molasses) was placed in the bowl of the pipe, then held over the flame of the lit oil lamp. Once the opium softened and started to bubble and evaporate, the smoker would inhale the smoke through the mouth, leading to the expression that opium addicts "eat smoke."

At the very end of the Qing dynasty, a serious attempt to end opium use was instituted, and all opium dens were closed in 1909. However, foreign importers and local warlords continued to encourage opium smoking, for financial gain and political control. Intermittent attempts to close opium dens in Shanghai were tried in the 1930s by General Chiang's provisional government. However, as the general himself was known to enjoy a pipe or two (or more) when visiting his favorite brothels, it's not really surprising these attempts were unsuccessful.

Once the Communists took over China in 1949, the opium trade and prostitution made quick exits. But prostitution has been around for a very long time and did not disappear entirely. Under the strict Maoist regime, however, it was controlled. But today it is again to be found throughout China, although it will never again achieve the status and acceptance it enjoyed in 1930s Shanghai.

★ Opium smokers. (JOHN L. STODDARD'S LECTURES. Boston: Balch Brothers Co., 1897.)

PART III

THE MOVIES

Star Power and Style

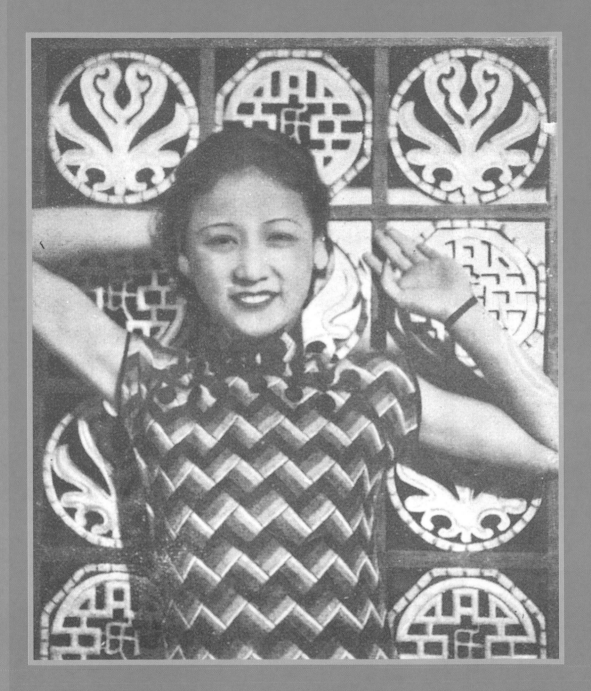

CHAPTER 6

Femmes Fatale, Fashion, and Feminism

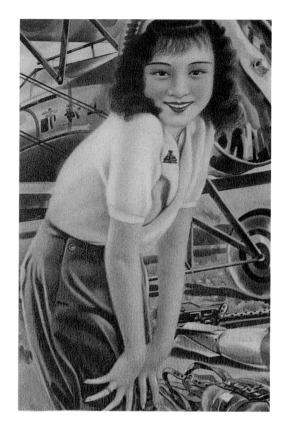

"THE DOMINANCE OF HOLLYWOOD MOVIES SERVED AS BOTH
A MODEL AND A FOIL FOR NATIVE FILMMAKERS,
REGARDLESS OF THEIR INTELLECTUAL BACKGROUNDS
AND IDEOLOGICAL PERSUASIONS."

—Leo Ou-Fan Lee, *Cinema and Urban Culture in Shanghai 1922–1943*

★ A high-flying Shanghai girl, late 1930s.

★ (Opposite) Movie star and cover girl
Mei Lin, 1931.

CINEMA ARRIVED IN CHINA as early as 1895 with the Lumière films
from France, known as "electric shadows." The first homegrown product was
a short film starring a Chinese classical opera favorite Tan Zinpei. The first fea-
ture length film came in 1921, titled *Yan Ruisheng*, and was based on an actual
murder case that had been much in the news in China. Early Shanghai films
included *Beating the Town God, The Difficult Couple,* and *Five Blessings at the
Threshold*, released in 1913. In 1922 a comedy directed by Zhang Shichuan,
Laborer's Love, was seen in the West. It was, of course, a silent film with Eng-
lish and Chinese subtitles. The first Hollywood-produced "talking picture"
debuted in the United States in August 1926 and by early 1927 theatres in
Shanghai were showing Hollywood "talkies."

★ On set at a working film studio, circa 1925.

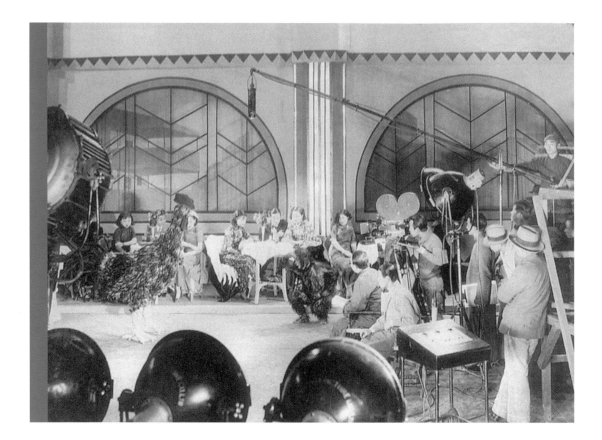

The Shanghai film industry grew quickly from only five studios in 1910 to nearly fifty by 1925. And by 1927 there were 151 film production companies. By the early 1930s many of the smaller companies had closed. Four major studios stood above all the others, Mingxing (Star), Lianhua (United), Tianyi (Unique), and Yihua (China Artist). The bombing of Chapei and Hong Kew in the Chinese City by Japanese warplanes on January 28, 1932, prompted temporary support of all things Chinese (as opposed to foreign imports) and local film production increased between 1932 and 1934. Lianhua released twenty-five films during this period, and Mingxing released nineteen. But this productivity would be limited. With the Japanese invasion on the horizon, life as both the Shanghailanders and Shanghainese had known it was soon to end.

★ In the early days of Chinese cinema, film studios promoted their female stars as educated women and often posed them reading books to reinforce this idea. The photograph (left), circa 1919, was more likely used as a source for a calendar poster. The model is perched on a carved side chair and covered from neck to ankle in a long jacket with a straight skirt. Her tiny feet appear to be encased in lotus slippers and she wears antique hair ornaments in an elaborate coiffure. An historical backdrop of junks under sail appears behind her. In the second photograph, circa 1930, the model's coat daringly reveals her stockinged legs and high-style, high-heeled shoes. Atop her bobbed hair is an interesting interpretation of a cloche-style hat. She appears relaxed and comfortable in the Western-style armchair.

But during the "golden age" from the mid-1920s to the late 1930s, the movies and the movie industry would have a profound impact on Chinese culture, and especially in Shanghai, where cinema had become an important form of entertainment—and source of information. In this sophisticated city, both foreign and Chinese residents had leisure time and money to spend, commodities not found in the countryside and provincial towns. Although French, Russian, and English films made their way to Shanghai screens, it was from Hollywood movies that new glamour—and new ideas—emanated, and it was Hollywood that inspired and spurred on the burgeoning Shanghai film industry. And it didn't hurt that the eight major Hollywood studios had distribution offices in Shanghai, each associated with a specific theatre.

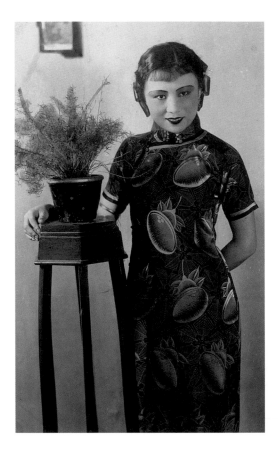

★ Publicity still of a confident starlet, circa mid-1930s, looking boldly at the camera, her figure tantalizingly revealed by the form-fitting qi pao.

From Hollywood came an idealized vision of beautiful people wearing extravagant clothes living an easy life in expensive settings. It was a beautiful escape from reality that corresponded perfectly to the way the foreign population of Shanghai lived day-to-day. They existed in a sheltered, manufactured world, content to ignore the pathetic conditions under which so many Chinese lived, as well as the dangerously unstable political situation. The Westerners' Shanghai was built on a foundation about as secure as, and not far removed from, the dream world they saw in Hollywood movies.

For Chinese women, however, what they saw on screen changed their view of the world and themselves. Women saw women on film with careers, careers that would have been unthinkably "inappropriate" just a decade earlier because they required interaction with men. But the Shanghai of old, the city where women from wealthy families who did not have to work were confined to the seclusion of their homes by the severe rules of *li chiao* (Confucian propriety), was no more. The close of the Qing dynasty (1911) and the rise of the Republic (1912) had opened many doors of opportunity to women. They were allowed to participate in professions previously closed to them and acting, once reserved for men only, beckoned. Chinese audiences were not used to seeing female actors on stage, other than those they classified as prostitutes who performed with small traveling theatrical troupes. Movies brought female actresses into the mainstream, and audiences quickly showed their enthusiasm. These cinema stars in turn raised the social status of their profession, so much so that they were widely looked up to as role models, particularly in their style of dress.

Intellectuals were among the first in Shanghai to embrace foreign cinema, seeing it as an aid in social education. Studios were anxious to promote their

★ Hollywood publicity still, circa 1925, of MGM
actress Eleanor Boardman selecting shoes.

★ Open-toed black suede silk embroidered shoes with gold leather sling backs, circa mid-1930s. (Author's collection, Chris Roche Photography.)

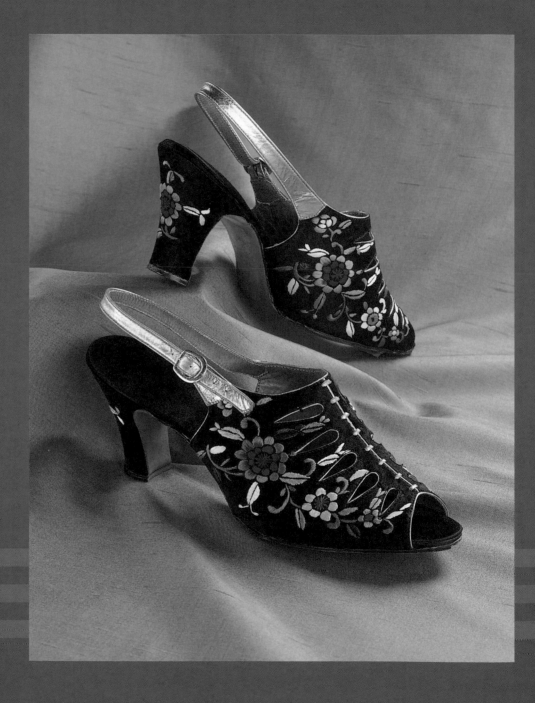

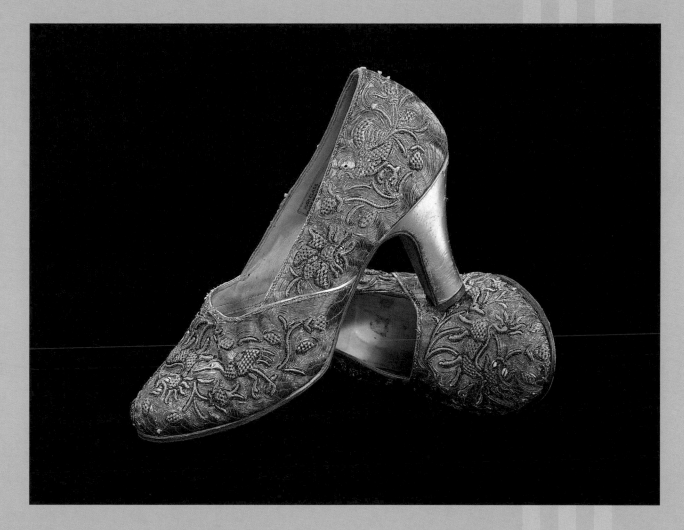

★ Gold leather and magnificently embroidered silk pumps, circa late 1930s. This style of embroidery, called couching, is executed with fine silk threads that have been covered in pure (so it is soft and flexible) gold or silver foil. The covered threads are laid side-by-side then caught in place with tiny, nearly invisible stitches in a plain silk thread. A costly and laborious process, it allowed for highly imaginative three-dimensional designs. The fanciful flowers and dragons on these shoes display an exceptional example of the needle-worker's art. (Author's collection, Chris Roche Photography.)

★ Soo Hong Chew with his bride Wee Gam Har, 1937. This pose is more casual and affectionate than the earlier family portraits shown on pages 48 and 51 (although the backdrop appears to be the same traditional pagoda garden landscape). This may be attributable to the movies in which Chinese couples saw other couples interacting less formally and more romantically with one another. (Photo courtesy of Ron Chew, and The Wing Luke Asian Museum, Seattle, Washington.)

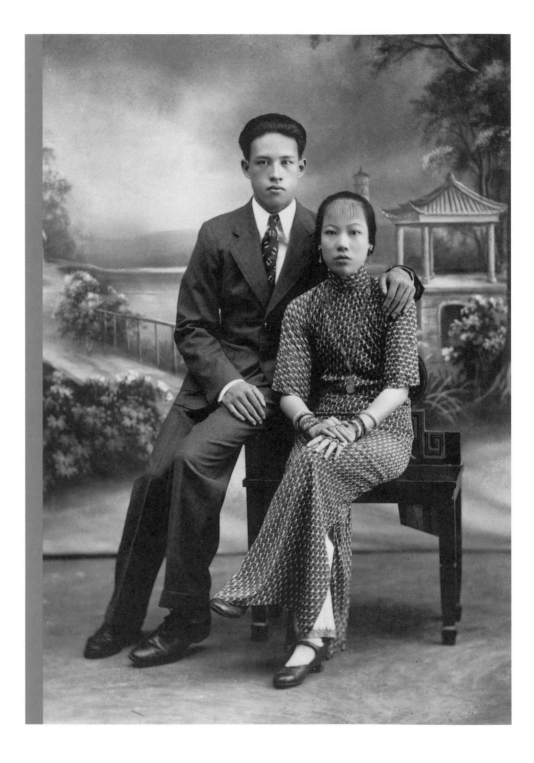

★ Hollywood greats Myrna Loy and William Powell, circa 1934, had a very modern on-screen relationship that would have been unheard of in China. Although a movie like the THE THIN MAN was essentially pure entertainment, it was important for Chinese women to see what was culturally acceptable between a man and woman beyond their borders.

new stars as modern, educated women. Their stars were photographed reading books in addition to conventional glamour shots. This was quite a departure from the typical Hollywood-style promotion in which female stars were portrayed as the personification of sexuality. Chinese stars, on the other hand, were supposed to exemplify modern femininity. And this was demonstrated by how they posed and dressed for the cameras. Chinese actresses wore the modest neck-to-ankle-length qi pao, whereas sexy Hollywood sirens often wore considerably less.

Hollywood films and publicity stills, however, revealed more than just female beauty. They revealed a world of relationships between men and women. Shanghai girls saw relationships on screen and in print that were romantic rather than arranged, that resulted from feelings and choices rather than economic need and social expectation. The way the Hollywood film stars looked—clothing, hair, makeup—sent messages of confidence, security, and strength. And Shanghai girls led the charge toward those ideals.

Yin Mingzhu (Pearl Ing) was the first leading actress of Chinese cinema, a distinction made easier by the fact that she was married to her producer who started the Shanghai Film Company. Pearl was born in 1904 to a poor but intellectual family. Her grandfather was a court official and her father was a painter. She attended the Shanghai Sino-Western Girl's School, where she studied dancing and singing. Her classmates found her too foreign for their taste, and called her Foreign Fashion (F. F. for short), a nickname that stuck with her for life.

Another Chinese actress to achieve cinematic fame was Wang Hanlun. She also was the only famous film actress with bound feet. Her mother may have followed tradition and bound her daughter's feet, but her father was

★ Although "pajama" is a Hindustani word, the combination of qi-pao styling and two-piece pajama comfort created a craze for lounge-wear in the 1920s. (Author's collection, Chris Roche Photography.)

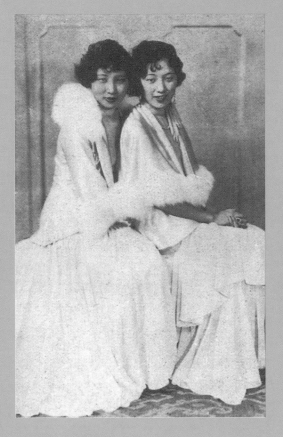

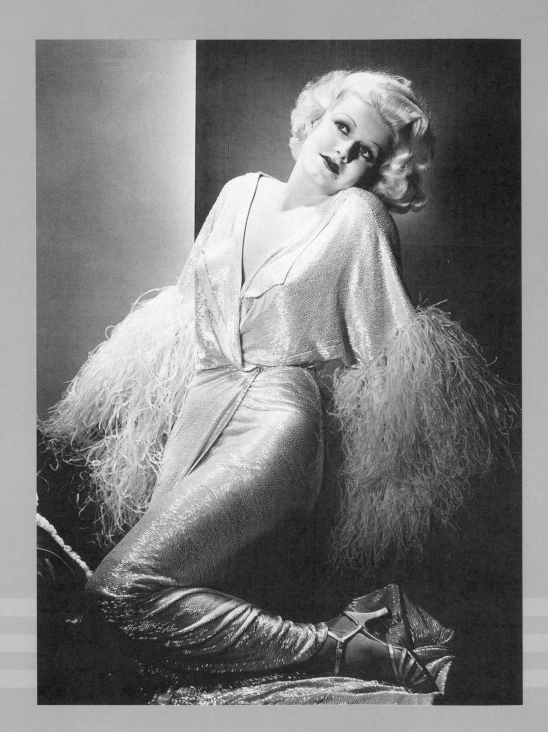

★ (Above) Cinema stars Chou Zhou and Kuei Gui, 1931. Although they are totally covered, the choice of feather trimmed satin evening jackets over sweeping Western-style evening gowns, and even their loosely curled short hair, was sexually suggestive and owed much to the more provocatively posed and scantily clad Hollywood publicity stills like this one of Jean Harlow, circa 1933.

"COSMETICS OF THE STARS"

Jean Harlow, popular Star, and Max Factor, using Max Factor's Face Powder.

★ Shanghai girls knew all about Max Factor, the man who innovated movie makeup in Hollywood, including lip-gloss, pancake foundation, and false eyelashes. In 1928 Factor Studios published a 46-page booklet filled with photographs of Max Factor himself making up all the screen idols of the day. This innovative giveaway item undoubtedly found its way to the Shanghai movie industry where it influenced the stars and fans alike. Who could resist copy like this? "Dream a moment....then fly on wings of imagination to Hollywood. It is night-time at one of the big studios.... A Rolls-Royce silently and gracefully rolls up to the entrance....The star alights and hurries to her dressing room....At her make-up table Max Factor is working....There is something new tonight....The genius in make-up has developed another discovery....Tonight color pigments will be harmonized in cosmetics for the first time....As the star is being made up she wonders if the experiment will be a success....The camera will tell, for the camera never lies....On the set, under the Klieg lights, the director marvels at her radiant beauty....Max Factor enthusiastically smiles approval....Intuitively she senses a success as the camera starts clicking....Now, later...they review the film in the projection room....and as the scene flashes on the screen, the rare beauty of the star appears so lovely, so natural, so alluring, that Max Factor realizes the severe test of the Kleig lights had caused him to develop a revolutionary idea in cosmetics."

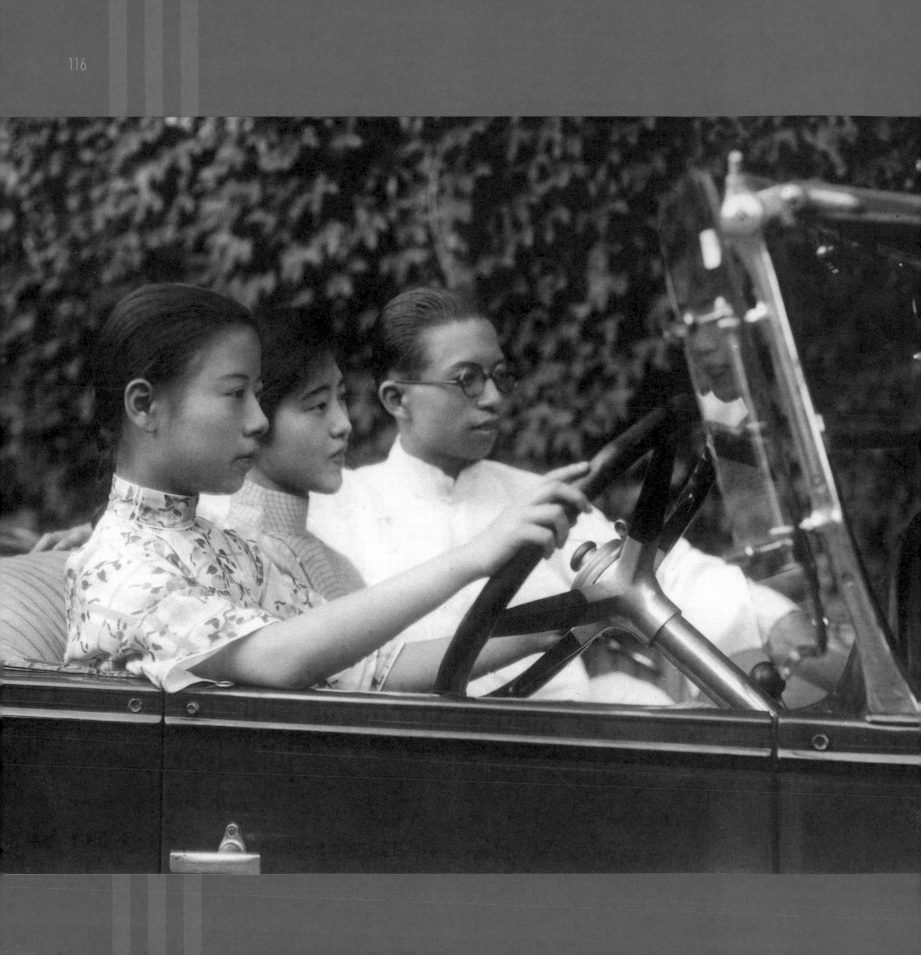

modern-minded enough to send her to St. Mary's College in Shanghai. Wang Hanlun spoke fluent English, a practically unheard of accomplishment for a Chinese girl at that time. Before her movie career, Wang Hanlun was a primary school teacher, and later worked as a typist for the British and American Tobacco Company. Ironically, after achieving fame in the cinema, she became involved in a lawsuit over the use of her name on a brand of cigarettes. Refusing the settlement offered, she asked only to halt the commercial use of her name.

Wang made ten silent films between 1923 and 1928, although she didn't enter the industry intent on becoming a star. It was the opportunity to make real money that drew her, something she could not expect in her previous jobs. Most of her films were stories of romance between a man and a woman, and were called "the style of mandarin duck and butterfly."

Wang Hanlun's early retirement may have been due to eye problems caused by working under the charcoal lamps used on silent film sets. However, she went on to yet another career, opening the Hanlun Beauty Salon in the French Concession.

The most famous actress of the period was Wu Die, born Hu Rui-hua (1908–1989), and popularly known as Butterfly Wu. A student of the Chinese classical opera star Mei Lan-fang, she came to the movies well trained. She became so popular that when she married Shanghai businessman Eugene Peng on November 23, 1935, it was a major news event all over China. No detail was too small to be picked up by the press, including the butterflies that adorned her wedding invitations, and the white velvet butterflies that flittered on her silk tulle veil that cascaded over an eight-yard train of silk lace. And the wedding cake got almost as many column inches as the bride. Said to be as

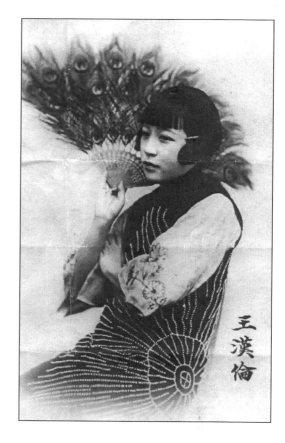

★ Silent screen star Wang Hanlun was the only actress who had bound feet to achieve stardom.

★ (Opposite) With mobility, from both the physical restrictions of bound feet and the social restrictions of staying home, the roles of women in Chinese society changed irrevocably. And, as with so many changes in Chinese culture, Shanghai was on the leading edge. These young women with Liu Hao-Sun in one of his many imported automobiles, circa 1933, were literally in the driver's seat. (Collection of Edith Liu.)

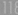

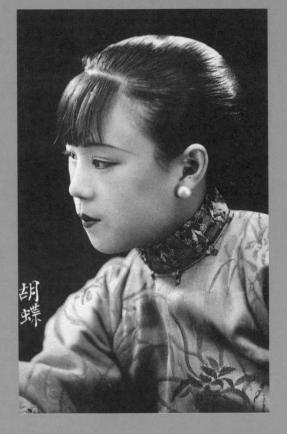

★ (Above) China's most famous film star, Wu Die, was popularly known as Butterfly Wu.

★ It is probably no coincidence that this calendar girl bears a striking resemblance to film star Butterfly Wu. (Author's collection, Chris Roche Photography.)

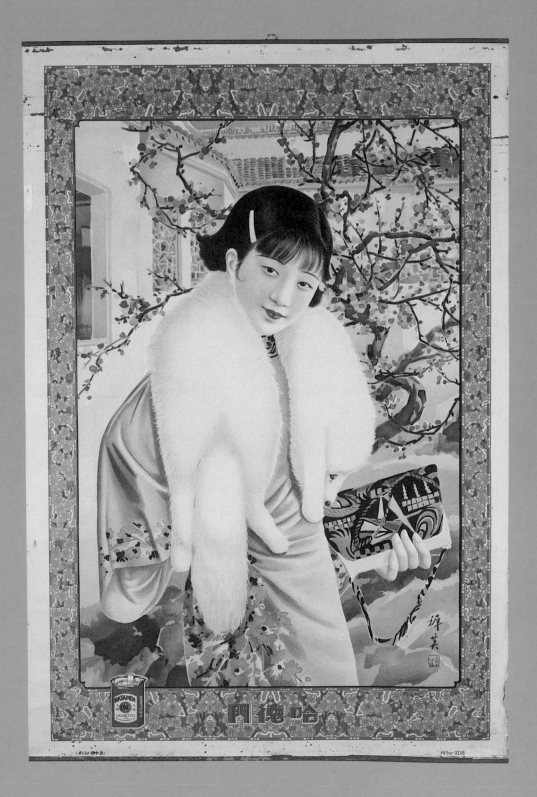

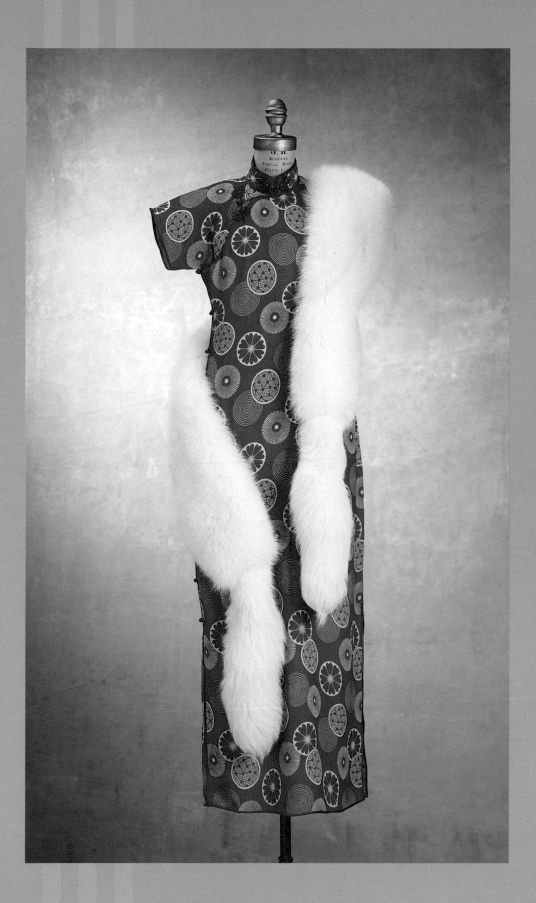

Qi pao, circa 1935, with a luxurious white fox stole. (Author's collection, Chris Roche Photography.)

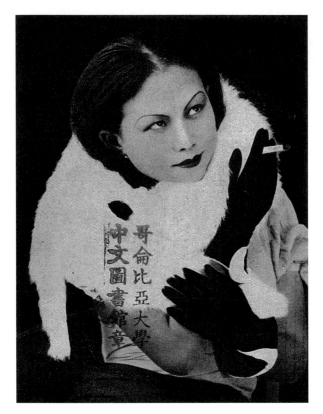

★ Swathed in white fox, popular film star Hsu Ling Xu Ling was a glamorous (though posthumous) cover girl in 1937.

high as a pagoda, it had to be if it was to feed the more than 2,000 guests that attended the wedding dinner at the Far Eastern Hotel!

By the time China was actively at war with Japan, Butterfly Wu was the established mistress of the notorious and much-feared General Dai Li, head of Chiang Kai-shek's Special Branch of Military Affairs Commission Bureau of Central Investigation and Statistics—the secret police. Her husband accepted the situation, having been given a job by Dai Li that offered him opportunities for profiteering in Kunming. It is ironic that the beautiful star so obsessed the infamous General Dai, she indirectly was the reason for his death. Dai Li was on his way to Shanghai when he had a fatal automobile accident. The reason for this journey? To meet with the equally infamous gangster Big Ears Du. The purpose of the meeting? To ask Du, who could arrange virtually anything, to try to arrange a divorce for Butterfly Wu because General Dai wanted so desperately to marry her. In 1939, she left Shanghai to live in Hong Kong.

Another famous actress of the 1930s was Ruan Lingyu, who tragically committed suicide on March 8, 1935. Nearly 20,000 mourners (mainly women) attended the viewing of her body on March 11, and for her burial on March 14, the streets where the funeral procession passed were lined with many thousands of mourners.

Ruan learned her craft on the job, making five films for Mingxing, then moved on to Great China-Lily Film Company in 1929. She moved again in 1930 to Lianhau Studio where she found stardom. It has been observed that still photographs of Ruan always show her looking rather sad. There is speculation about whether this can be attributed to the studio wanting her to look like the tragic women she portrayed in film, or reflected her personal problems that ultimately led to her early death.

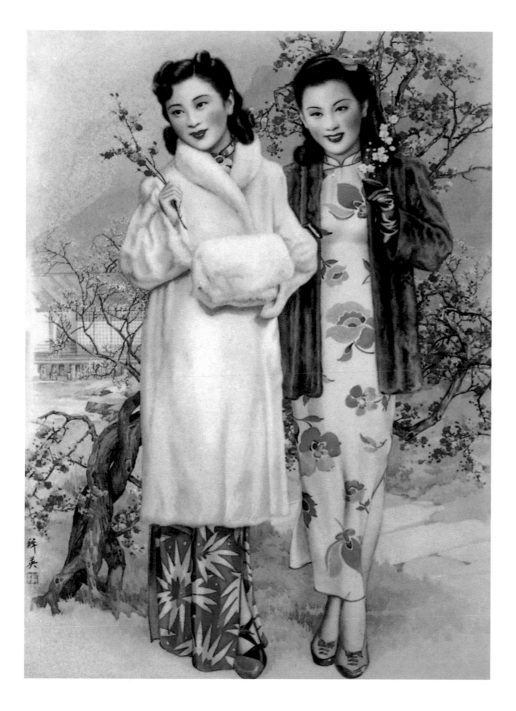

★ Shanghai girls loved to be seen arriving at film openings and nightclubs, their perfectly coifed jet-black hair and precisely made-up faces floating above mountains of luxurious fur, such as ermine, mink, beaver, broadtail, sealskin, fox, chinchilla, or sable. The inspiration for their magnificent fur wraps came not from their northern nomadic ancestors who wore fur for protection from the brutal elements, but from Hollywood stars like Greta Garbo and Marlene Dietrich, whom they saw swathed in fur on screen and in print. Some of the more conservative Shanghainese film stars adapted the Chinese convention of wearing fur on the inside of a coat or jacket, choosing to secret their luxury.

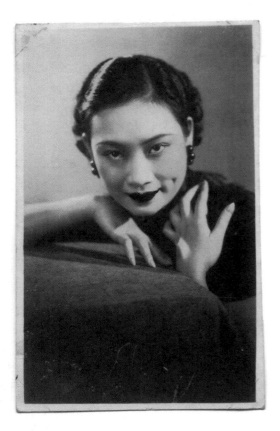

★ The legendary actress Butterfly Wu was easily identifiable by the dimple on her left cheek.

In the early years of Shanghai cinema, the first generation of actresses had no choice but to promote themselves. The early Chinese studios did not support them with the big campaigns that the Hollywood stars enjoyed. However, by the 1930s star promotion and competition had become a concern for the studios, so they began to stress the good looks of their actresses, as well as their education. Fashion spreads showing off the physical attributes of the Chinese stars began to appear next to demure portraits of young starlets reading or painting or pursuing some other respectable intellectual activity.

Magazines were the Shanghai studios' most effective tools for promoting their rising stars. However, in the 1920s it was the top courtesans and their clothes that were featured in the popular magazines, particularly the Mosquito Journals (*xiao boa*), a combination of literary articles, gossip columns and photo layouts. The courtesans were the main attraction, and were described in detail, in pictures and in print: what they wore, where they went, and with whom. And like today's tabloid publications, they often printed scandalous accounts of the courtesans' romantic involvements with well-known wealthy men about town.

But by the 1930s the leading ladies of Shanghai cinema were easing the courtesans off the covers and pages of popular magazines, like *The Young Companion*, which promoted starlets with feature stories, fashion layouts, and advertising. Some magazines, such as *Silver Star* (Yinxing), were totally dedicated to Chinese stars and their movies, while newspapers, such as the popular *Women Daily* (Funu Ribao) put America's leading ladies, like Joan Crawford, Marlene Dietrich, Irene Dunne, Dolores Del Rio, Norma Shearer, and Shirley Temple, right next to Butterfly Wu and Ruan Lingyu.

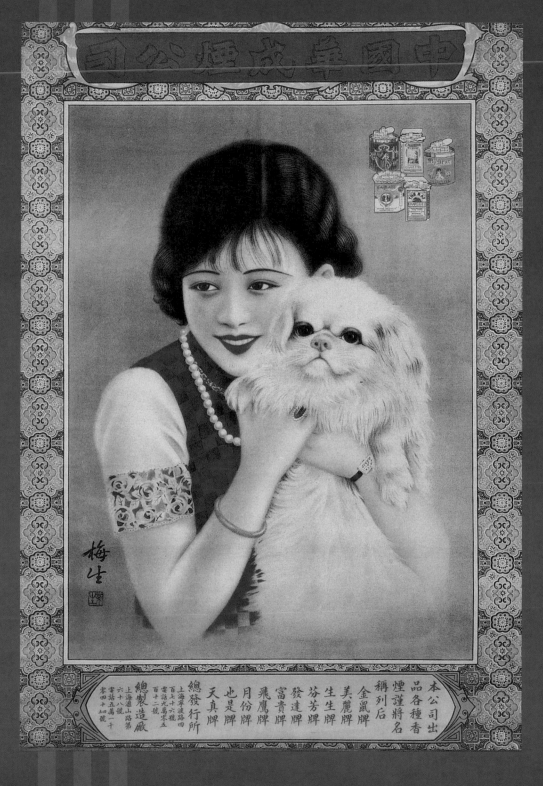

★ Calendar girls were often popular film stars from the Shanghai movie industry. They set the trends all over China for fashion, cosmetics, hair, accessories, fabrics, prints, and even pets! (Author's collection, Chris Roche Photography.)

★ Screen legend Irene Dunne in an exquisitely tailored suit with a silver fox collar and muff from the mid-1930s.

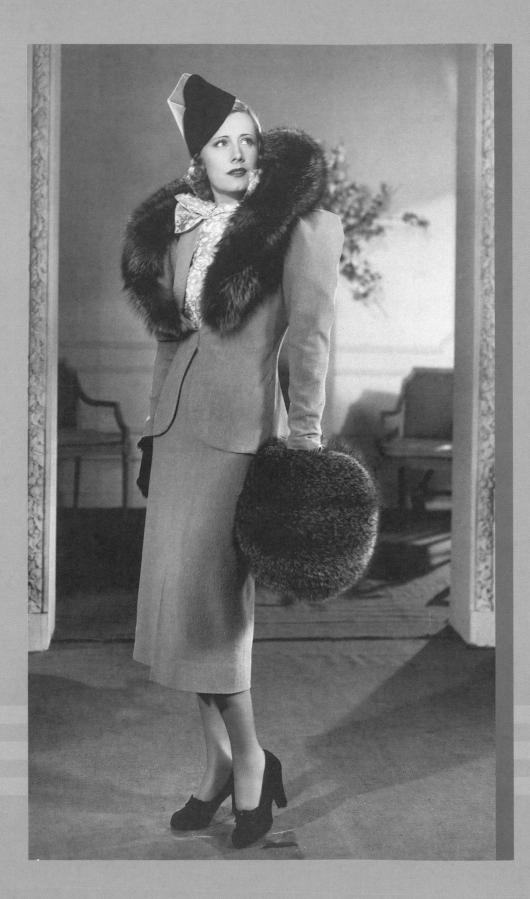

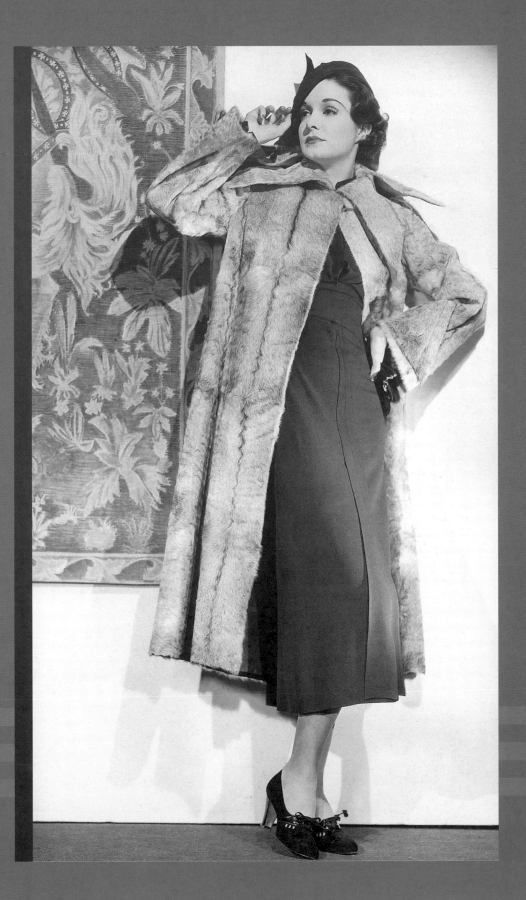

★ Paramount actress Gail Patrick in a gray broadtail coat, circa 1935.

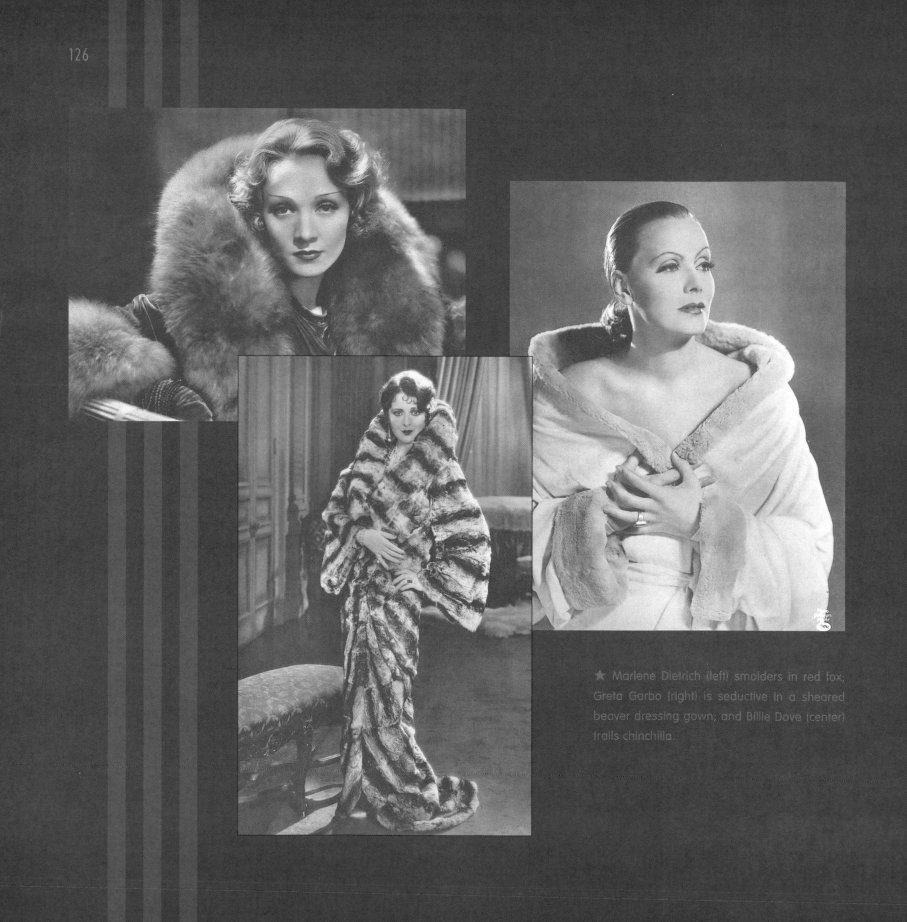

★ Marlene Dietrich (left) smolders in red fox; Greta Garbo (right) is seductive in a sheared beaver dressing gown; and Billie Dove (center) trails chinchilla.

★ A trio of screen goddesses, Norma Shearer (left), Joan Crawford (center), and Rosalind Russell (right), appeared together for MGM in THE WOMEN in 1939. Their gowns are by Adrian and each reflects and reveals the character that wears it through the design, the fabrics, even the colors.

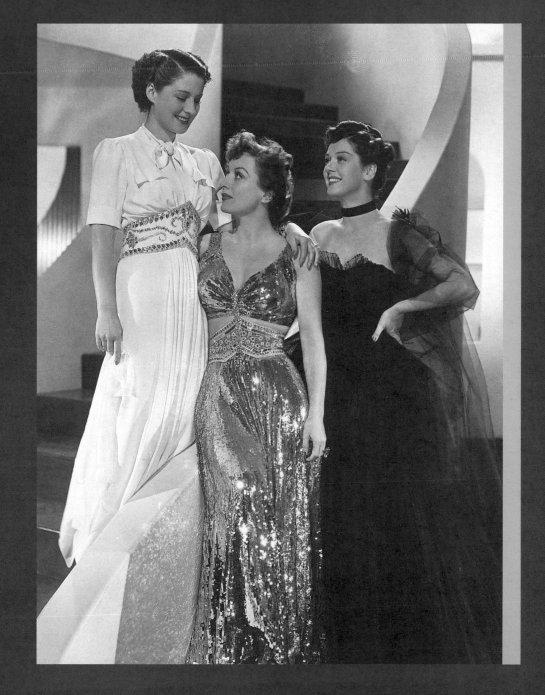

★ One the notorious and wildly popular Mosquito Journals. In this issue (shown actual size), an American starlet appears on the front cover, a Chinese starlet on the back, and a chorus line of cabaret girls (whose routines were doubtless influenced by the films of Hollywood director/choreographer Busby Berkeley) appears inside.

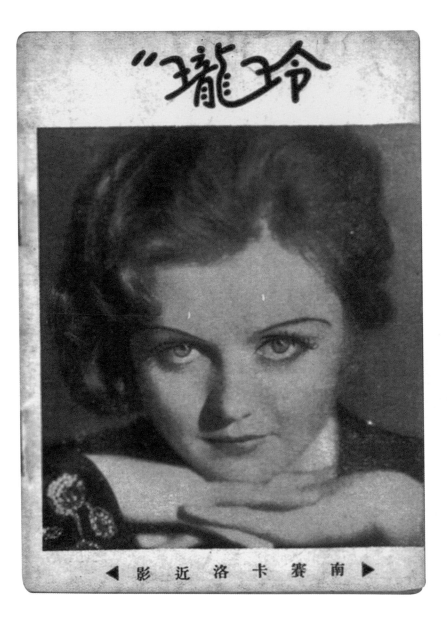

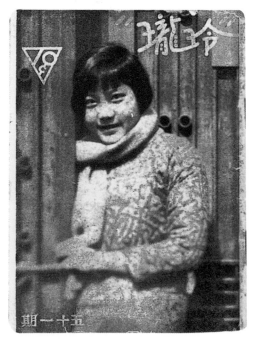

Fan mail, so much a part of the Hollywood promotional machine, also became important in China, although in the early days proved somewhat cumbersome. Because there were no screen credits, a fan wishing to contact a favorite star had to write to the studio and ask to have their letter forwarded

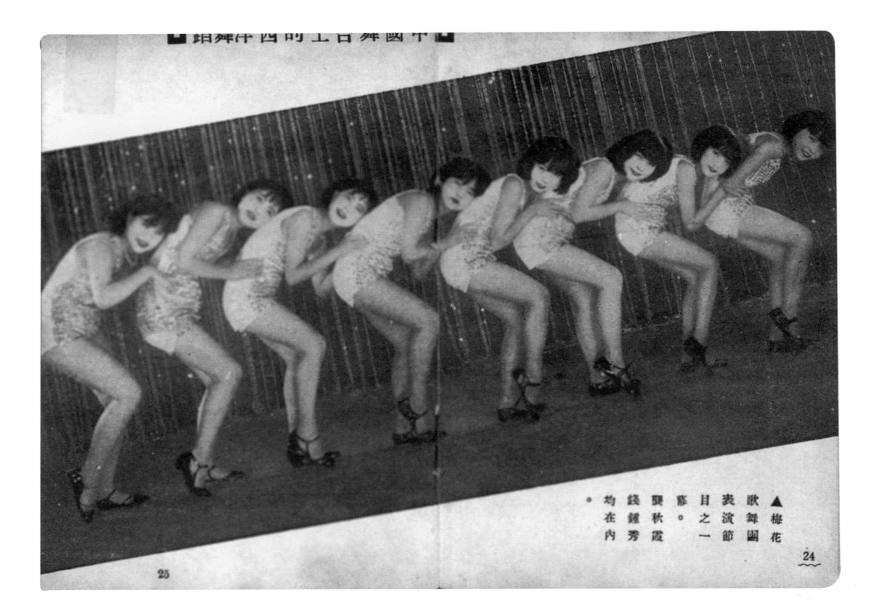

to the actress. However, having no name for her they would write something like, "Please forward to the actress who wore the qi pao with big flowers on it in such and such a film." Thus, what a star wore became an important component of her identity with her fans.

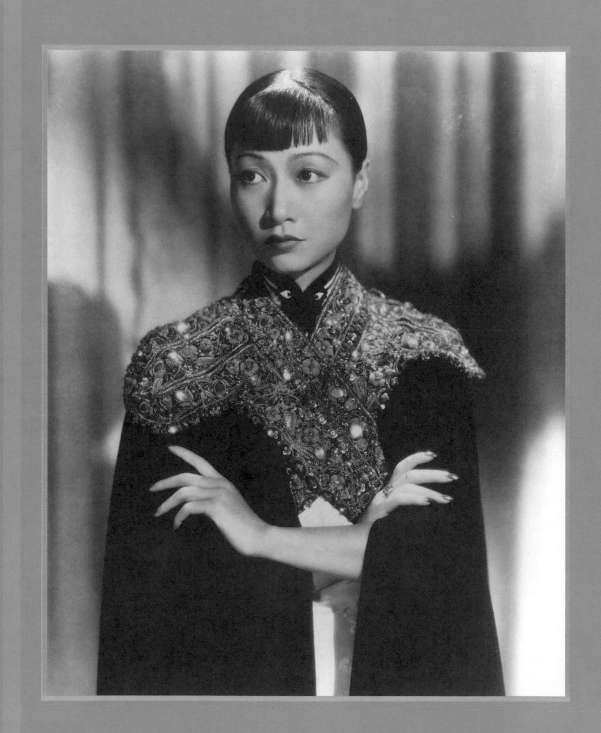

Anna May Wong: American Beauty and Asian Icon

THE GREATEST ADVERTISEMENT in the West for the new Shanghai style known as the qi pao, or cheongsam, was a beautiful third-generation Californian of Chinese descent born above her father's laundry on Flower Street in Los Angeles' Chinatown on January 3, 1905. One of seven children, her Chinese name was Wong Liu Tsong, which translates to Frosted Willow Blossoms, but she later chose Anna May while retaining her last name, Wong.

Americans and Europeans had a fascination with the exotic and sometimes sinister tales of the Far East, and in particular China. Throughout her career, Anna May Wong played what would become the archetype of the Oriental temptress—sensual, sophisticated, and usually sinful in some way. This, as much as her beauty and talent, led to her popularity. But her unique personal style was another major factor in her success. At the peak of her career, from 1928 to 1938, she frequently chose to wear variations on the cheongsam

★ (Opposite) Anna May Wong was considered one of the world's best-dressed women in 1934.

★ Americans had exotic and, sometimes, sinister notions of "the Orient" that found aesthetic expression in film and design. A program from Grauman's Chinese Theatre, which opened in 1927.

★ In Hollywood, Anna May Wong played a stunning array of sirens and spies, traitors and temptresses, prostitutes and princesses.

SHE BARED THE SECRETS OF A THOUSAND DEATHS!

Adolph Zukor presents

"DAUGHTER of SHANGHAI"

with ANNA MAY WONG

Philip Ahn · Charles Bickford · Larry Crabbe · Cecil Cunningham
J. Carrol Naish · Anthony Quinn · John Patterson · Evelyn Brent
Screen Play by Gladys Unger and Garnett Weston · Based on a Story by Garnett Weston
DIRECTED BY ROBERT FLOREY · A PARAMOUNT PICTURE

and, needless to say, her studio-designed versions were exceptionally glamorous and often coupled with spectacular jewels and furs. And her willowy figure made her the perfect model to display the clothes she inspired. In 1934, the British Mayfair Mannequin Society designated her as the world's best-dressed woman. More than seventy years later, no one has ever equaled her.

Anna May Wong knew from a very young age that she wanted to be an actress and, contrary to her family's wishes, she got a bit part in 1919 in MGM's *The Red Lantern* starring the silent screen legend, Alla Nazimova. Her first major role was in *The Toll of the Sea*, also for MGM, released in 1922 and Hollywood's first Technicolor film. An important part, but not a starring role, came up in 1924 in the Douglas Fairbanks vehicle *The Thief of Baghdad.* Still in her teens, other roles followed, but the studio chiefs would not cast an Asian girl in a starring role. In 1928, a great leading part written specifically for an Asian woman in *The Crimson City* was being cast, but a young Caucasian actress from Montana, Myrna Loy, was chosen and Anna May Wong was relegated to a supporting role.

Enough was enough. She packed up and moved to Europe where she stood a better chance of obtaining important roles. After several very successful films in Germany, she moved on to England, where she starred in a play with a role written specifically for her. Her leading man? A young actor named Laurence Olivier. She also starred in a film, *Tiger Bay,* about which as much was written concerning the cheongsam she wore in it as about the film itself!

Although embraced both professionally and socially in Britain and Europe, Anna May Wong returned home in 1931, and the following year she played the role that brought her the greatest fame of her career. In 1932 Josef von Sternberg cast her in *Shanghai Express* in the supporting, but important,

★ Combining old and new, Anna May Wong wears a slender silk cheongsam edged in antique embroidery. Her always sleek, signature hairstyle was in radical contrast to the "marcelle" waves and fluffy bobs so popular during this period.

★ (Opposite) Top Hollywood costume designer Travis Banton used long lean lines, a high collar, and deep side slits on this shimmering tunic and skirt for an unmistakably Asian theme.

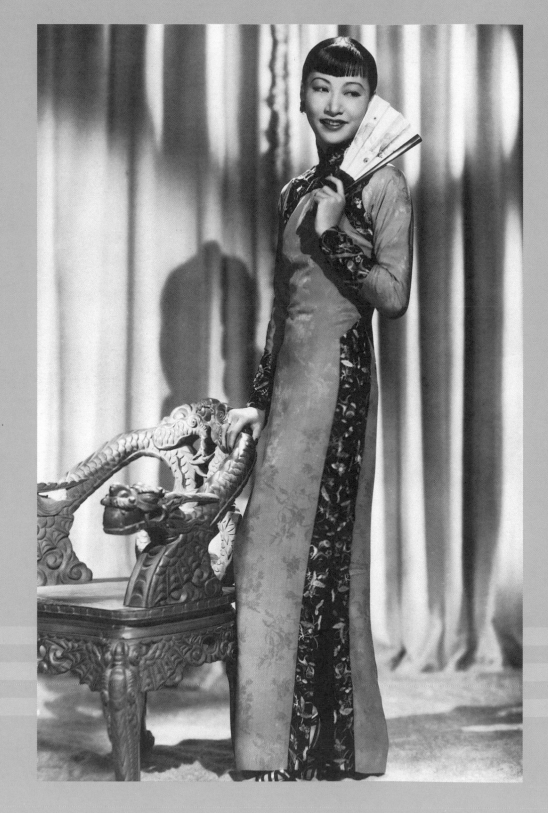

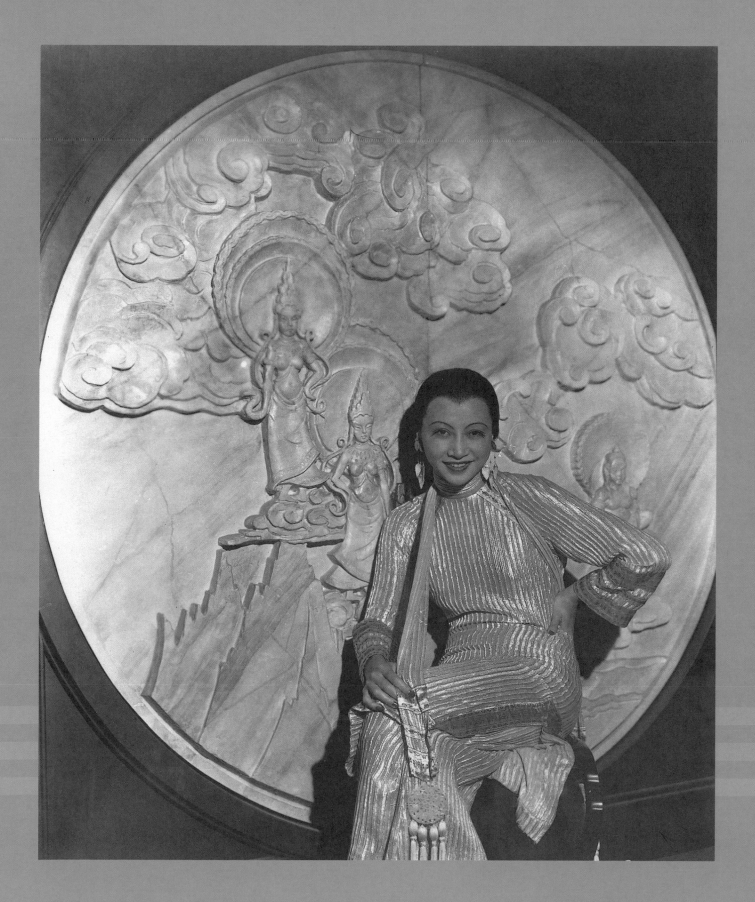

role of Hui Fei, a prostitute who befriends the lead, Shanghai Lily, played by Marlene Dietrich.

Many films followed and Anna May Wong's popularity—and salary—continued to rise. By the late 1930s she was earning $6,000 per picture, a sizable sum in an economy just emerging from the Great Depression. However, she also continued to fight prejudice and the interracial taboos in American filmmaking. Although roles continued to come her way, the role of a lifetime was denied her. When MGM announced they were casting a film version of Pearl Buck's Pulitzer Prize-winning novel *The Good Earth*, it was clear that Anna May Wong was perfect for the lead character, O-Lan. Too perfect, perhaps, because the role went to an Austrian actress, Luise Rainer (who won an Academy Award for her performance). From a twenty-first century perspective, such a casting choice appears ludicrous. However, because a Caucasian actor, Paul Muni, had already been cast in the male lead, it was out of the question to cast an Asian actress opposite him in the role of his wife. Interracial co-mingling was only acceptable if the non-Caucasian actor/actress played a villain, criminal, or prostitute. But an Asian heroine with a non-Asian hero? Not feasible according to the obviously hypocritical social strictures of the period, strictures that did not apply in Europe and Britain.

On January 21, 1936, Anna May Wong left for her first trip to China, after securing a guarantee from U.S. Immigration that there would be no problem with her reentry. Interestingly, despite her immense popularity among Chinese movie fans, her reception in China was not exactly a warm one. Madame Chiang Kai-shek's New Life Movement reforms were greatly responsible for this, as the star's often less-than-wholesome film roles were contrary to everything the Movement represented. There was also resentment that she could

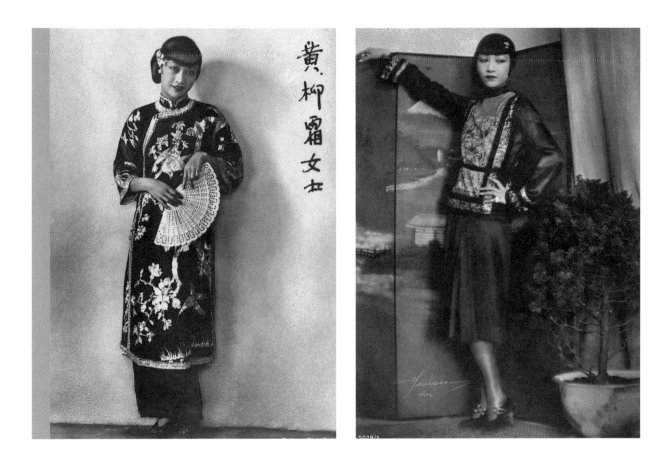

黃柳霜女士

neither speak nor write the Mandarin language. Newspaper reporters were particularly hostile toward her. When she visited her ancestral village of Chang On, oral histories from residents report that she was pelted with rocks upon her arrival there!

While in Beijing and Shanghai, Anna May Wong did study Mandarin and enjoyed the active social life of the international set. Among the Chinese who entertained her were famed Chinese classical opera star Mei Lan-fang, film actress Butterfly Wu, and Mme. Wellington Koo, whose husband was Ambassador to France, Great Britain, and the United States at various periods. Anna May Wong returned to the United States in November and, shortly thereafter, was on her way back to England.

★ (Left) Anna May Wong was photographed by Lotte Jacobi wearing a traditional Manchu-style embroidered robe. Berlin, 1931.

★ (Right) Anne May Wong posed for Lotte Jacobi in an unusual jacket fashioned from the panel of a traditional Han-style paired apron skirt. Berlin, 1931.

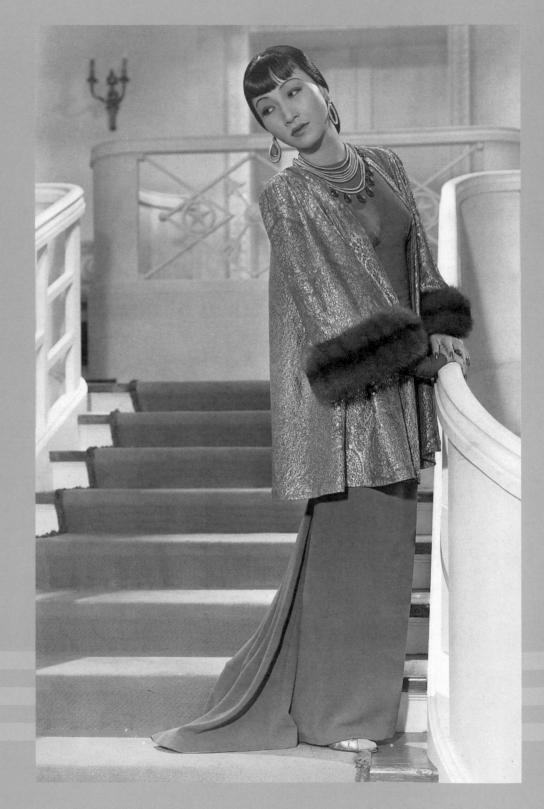

★ Luxurious sable, the fur of emperors, trims the gold lamé jacket worn over an emerald green crepe gown, designed by the great Edith Head for the 1937 film DANGEROUS TO KNOW.

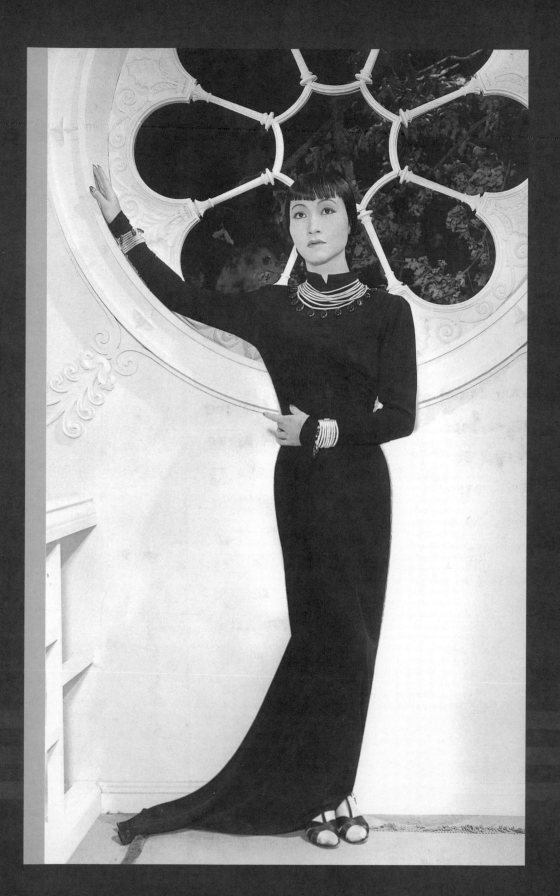

★ A stunningly severe black crepe variation on the basic cheongsam by famed Hollywood costume designer Edith Head for the 1937 film DANGEROUS TO KNOW.

★ Anna May Wong embodied the quintessential image of the "Oriental temptress" in this fanciful and daring costume for Lotte Jacobi's camera. Berlin, 1931.

In Britain, Anna May Wong was accepted in the very highest social circles and enjoyed universal popularity wherever she went. Such acceptance was extremely important to this highly accomplished woman, who spoke eight languages, was a marvelous athlete and scratch golfer, as well as a skillful actress.

In spite of Hollywood disappointments, Anna May Wong always remained a patriotic American and worked very hard for the USO, visiting American troops overseas during World War II. She also became very active in fund raising for Chinese war relief. In a life full of irony, it is particularly ironic that she received the greatest snub of her life from a Chinese woman. In 1943 Madame Chiang Kai-shek came to Hollywood and spoke to over 30,000 people at the Hollywood Bowl (a speech this writer attended as a child). While stars Loretta Young and Ingrid Bergman were invited to appear on stage with Madame Chiang, Anna May Wong was not. It was later learned that the exclusion was quite deliberate on the part of Madame Chiang, who apparently felt that her background of wealth and sophisticated education made her too superior to share a stage with a girl who had been born above a laundry.

In 1948, years of hard living caught up with the beautiful actress when she was diagnosed with Laënnec's cirrhosis. In 1961, at the age of 56, Anna May Wong died in her sleep. She was cremated and her ashes buried in an unmarked plot next to her mother's marked grave at Rosedale Cemetery in Los Angeles.

Despite a full and productive life filled with many successes, Anna May Wong's Hollywood career never gave her what she wanted most—equality of film roles with female Caucasian stars. However, as the only American woman of Chinese descent to become a significant presence in Hollywood and European films, there can be little doubt she inspired many of the newly emancipated daughters of Shanghai to seek carreers in the film industry and beyond.

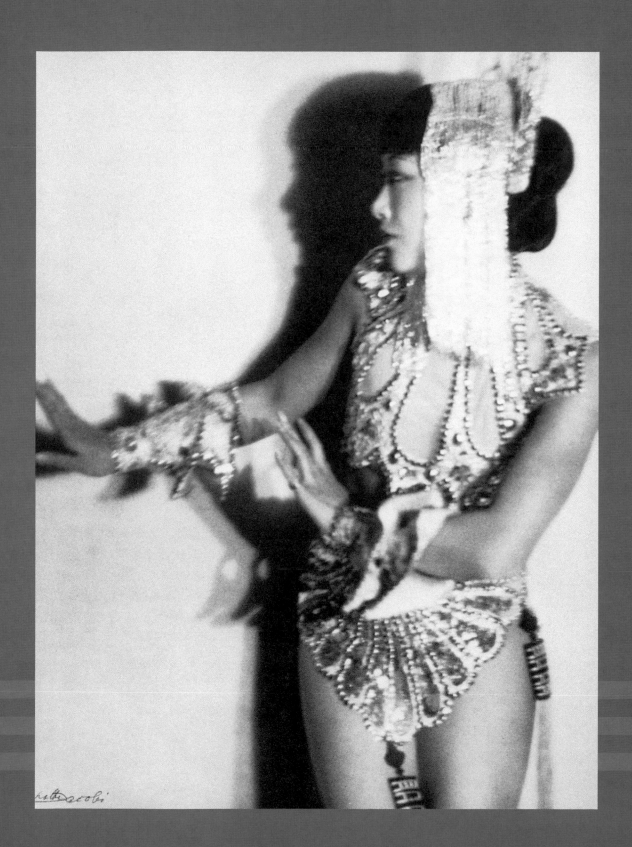

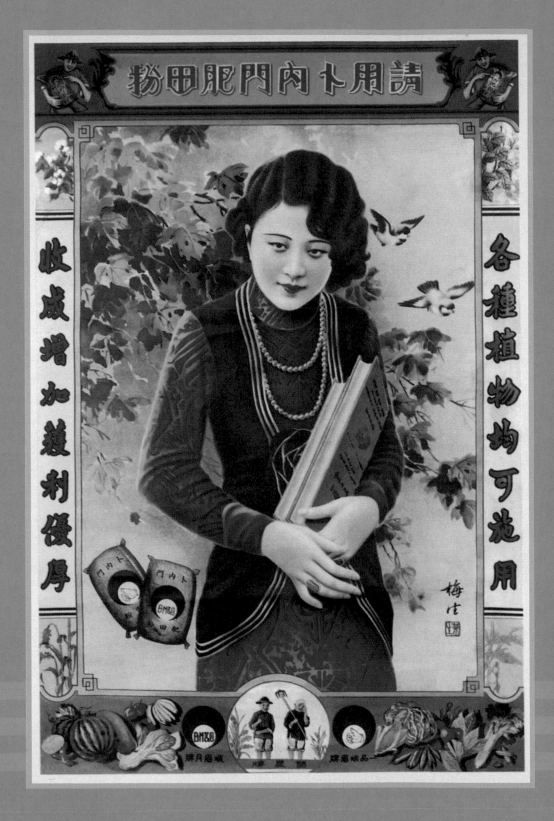

BIBLIOGRAPHY

Alley, Rewi. *Peking Opera.* Peking: New World Press, 1957.

American Women's Club. *The Dawn of Chinese Civilization.* Shanghai, 1921.

Amory, Cleveland (ed.), *Vanity Fair.* New York: Viking Press, 1960.

Angulo, Diana Hutchins. "China Days," *Social Register Observer.* Winter, 2001.

Arlington, L.C. *The Chinese Drama: From the Earliest Times Until Today.* Shanghai: Kelly and Walsh, Limited, 1930.

Art Deco Fashion and Jewelry. New Jersey: Chartwell Books Inc., 1998.

Baker, Barbara. *Shanghai: Electric and Lurid City.* Hong Kong: Oxford University Press, 1998.

Ball, J. Dyer. *Things Chinese.* Hong Kong: Oxford University Press, 1982.

Bickers, Robert. *Empire Made Me: An Englishman Adrift in Shanghai.* New York: Columbia University Press, 2003.

Bong, Ng chun, Cheuk Pak Tong, Wong Ying, and Yvonne Lo. *Chinese Woman and Modernity; Calendar Posters of the 1920s –1930s.* Hong Kong: Joint Publishing Company, 1996.

Bramson, Christopher Bo. *Open Doors: Vilhelm Meyer and the Establishment of General Electric in China.* Richmond, Surrey, England: Curzon Press, 2001.

Cairis, Nicholas T. *Passenger Liners of the World Since 1893.* New York: Bonanza Books, 1979.

Cammann, Schuyler. *China's Dragon Robes.* New York: The Ronald Press Co., 1952.

Clark, Hazel. *The Cheongsam: Images of Asia.* Hong Kong: Oxford University Press, 2000.

Cormack, Mrs. J. G. *Everyday Customs in China.* Edinburgh & London: The Moray Press, 1935.

Crisswell, Colin N. *The Taipans: Hong Kong's Merchant Princes.* Hong Kong: Oxford University Press, 1981.

Dai, Yunyun. *Shanghai Girl.* Shanghai: Shanghai Victoria Publishing House, 1999.

Der Ling, Princess. *Old Buddha.* New York: Dodd, Mead & Company, 1937.

Dickinson, Gary, and Linda Wrigglesworth. *Imperial Wardrobe.* Berkeley, CA: Ten Speed Press, 2000.

Dong, Stella. *Shanghai: Rise and Fall of a Decadent City 1842–1949.* New York: William Morrow, 2000.

Doolittle, Rev. Justus. *Social Life of the Chinese.* London: Sampson, Low, Son and Marston, 1868.

Elder, Chris. *China's Treaty Ports: Half Love and Half Hate.* Hong Kong: Oxford University Press, 1999.

Empress Dowager Cixi: Her Art of Living. Hong Kong Regional Council, 1996.

Fairbank, John King. *A Fifty Year Memoir.* New York: Harper & Row, 1982.

—*The Great Chinese Revolution 1800–1985.* New York: Harper & Row, 1986.

—*China: A New History.* Cambridge, MA: Belknap Press of Harvard University Press, 1994.

Fairservis, Jr., Walter A. *Costumes of the East.* Riverside, CT: Chatham Press, Inc., 1971.

Hahn, Emily. *Miss Jill From Shanghai.* New York: Avon Books, 1947.

—*China to Me.* Philadelphia: Blakiston Company, 1944.

Hall, Carolyn. *The Thirties in Vogue.* London: Octopus Books Ltd., 1984.

Hardy, Rev. E. J. *John Chinaman at Home.* London: T. Fisher Unwin, 1905.

Headland, Isaac Taylor. *Homelife in China.* London: Methuen & Co., 1914.

Herndon, Booton. *Mary Pickford and Douglas Fairbanks.* New York: W. W. Norton, 1977.

Hershatter, Gail. *Dangerous Pleasures: Prostitution and Modernity in 20th Century Shanghai.* Berkeley, CA: University of California Press, 1997.

Higham, Charles. *The Secret Life of the Duchess of Windsor.* New York: McGraw-Hill, 1988.

Honig, Emily. *Sisters and Strangers: Women in the Shanghai Cotton Mills 1919–1949.* Palo Alto, CA: Stanford University Press, 1986.

Hsia-sheng, Chen. *The Art of Knotting.* New York: China Institute, 1981.

Johnson, Linda Cooke (ed.), *Cities of Jiangnan in Late Imperial China.* New York: State University of New York Press, 1993.

Jones, A. G. E. *Ships Employed in South Seas Trade 1776–1861.* Canberra, Australia: Roebuck Society, 1986.

Johnston, Tess. *A Last Look: Western Architecture in Old Shanghai.* Hong Kong: Old China Hand Press, 1992.

—*Frenchtown Shanghai: Western Architecture in Shanghai's Old French Concession.* Hong Kong: Old China Hand Press, 2000.

Karamisheff, W. *Mongolia and Western China: Social and Economic Study*. La Tientsin: Librairie Francaise, 1925.

Koo, Madame Wellington. *No Feast Lasts Forever*. New York: Quadrangle/New York Times Book Co., 1975.

Kumar, Ritu. *Costumes and Textiles of Royal India*. London: Christie's Books, 1999.

Lee, Leo Ou-fan. *Shanghai Modern: The Flowering of a New Urban Culture in China 1930–1945*. Cambridge, MA: Harvard University Press, 1999.

Lethbridge, H.J. (ed.), *All About Shanghai: A Standard Guidebook 1934-5*. Shanghai: Oxford University Press, 1883.

Little, Mrs. Archibald. *Intimate China*. London: Hutchingson & Co., 1901.

Lu, Hanchao. *Beyond the Neon Lights*. Berkeley, CA: University of California Press, 1999.

Lynn, Jermyn Chi-Hung. *Social Life of the Chinese*. Peking-Tientsin: China Booksellers Ltd., 1928.

Mackerras, Colin (ed.), *Chinese Theatre: From Its Origins to the Present Day*. Honolulu: University of Hawaii Press, 1983.

McCormick, Elsie. *Audacious Angles on China*. Shanghai: Chinese American Publishing, 1922.

Menkes, Suzy. *The Windsor Style*. London: Grafton Books, 1987.

Miln, Louise Jordan. *The Flutes of Shanghai*. New York: Frederick A. Stokes Company, 1928.

"Mosquito Journal Magazines," *Lin Loon Ladies' Magazine*, Volumes 001, 002, 030, 045, 051, 052, 096, 268. Shanghai: 1922, 1931, 1932, 1937.

Mosley, Diana. *The Duchess of Windsor*. New York: Stein and Day Publishers, 1980.

Namioka, Lensey. *Ties That Bind, Ties That Break*. New York: Dell Laurel Leaf, 1999.

Nelson, Christina H. *Directly From China: Export Goods for the American Market, 1784–1930*. Salem, MA: Peabody Museum, 1985.

Pan, Ling. *In Search of Old Shanghai*. Hong Kong: Joint Publishing Ltd., 1982.

—*Old Gangsters in Paradise*. Singapore: Heinemann Asia, 1984.

Old Shanghai Movie Stars (1916–1949). Shanghai: Shanghai Pictorial Publishing House, 2000.

Photos of Old Shanghai: Old Theatrical Troupes. Shanghai: Shanghai People's Fine Arts Publishing House, 1932.

Priest, Alan. *Costumes from the Forbidden City at The Metropolitan Museum of Art*. New York: Arno Press, 1974.

Ricalton, James. *China Through the Stereoscope: A Journey Through the Dragon Empire at the Time of the Boxer Uprising.* New York: Underwood & Underwood, 1901.

Roberts, Claire (ed.), *Evolution & Revolution: Chinese Dress 1700s–1900s.* Sydney: Powerhouse Publishing, 1997.

Seagrave, Sterling. *The Soong Dynasty.* New York: Harper & Row, 1985.

Selivanova, Nina Nikolaevna. *Dining & Wining in Old Russia.* New York: E. P. Dutton & Co., Inc., 1933.

Sergeant, Harriet. *Shanghai: Collision Point of Cultures 1918–1930.* New York: Crown Publishers, 1990.

Shanghai Historical Museum (eds.), *The Vicissitude of Shanghai Folk Style and Features.* Shanghai: People's Fine Arts Publishing House.

Shu. *The Last Dreams of Old Shanghai.* Shanghai, 1999.

Sitwell, Osbert. *Escape With Me! An Oriental Sketch Book.* New York: Harrison Hilton Books Inc., 1950.

Snow, Helen Foster. *My China Years.* New York: William Morrow and Company, 1984.

Song, Jia Lin. *Old Calendar Pictures.* Shanghai: Shanghai Pictorial Publishing House, 1997.

Spunt, Georges. *Memoirs & Menus; Confessions of a Culinary Snob.* New York: Chilton Book Co., 1967.

Stephens, Thomas B. *Order and Discipline in China.* Seattle: University of Washington Press, 1992.

Strand, David. *Rickshaw Beijing: City, People & Politics in the 1920s.* Berkley, CA: University of California Press, 1989.

Tam, Vivienne. *China Chic.* New York: Regan Books, 2000.

Thayer, Mary Van Rensselaer. *Hui-Lan Koo.* New York: Dial Press, 1943.

Townsend, Mollie. *Shanghai: Reminiscences of a Missionary Nurse in China.* New York: Carlton Press, 1962.

Tsai, Chin. *Daughter of Shanghai.* New York: St. Martin's Press, 1989.

Varé, Daniele. *The Last Empress.* London: John Murray, 1935.

Vollmer, John. *In The Presence of the Dragon Throne.* Toronto: Royal Ontario Museum, 1976.

—*Ruling From the Dragon Throne.* Berkeley, CA: Ten Speed Press, 2002.

Von Sternberg, Josef. *Fun in a Chinese Laundry.* San Francisco: Mercury House, Inc., 1965.

Wakeman, Frederick, Jr. *Policing Shanghai 1917–1937.* Berkeley, CA: University of California Press, 1995.

Warner, Marina. *The Dragon Empress*. New York: Macmillan Co., 1972.

Williams, Edward Thomas. *China Yesterday and To-Day*. New York: Thomas Y. Crowell Company, 1932.

Wilson, Verity. *Chinese Dress*. London: Victoria & Albert Museum, 1986.

Yi, Bin. *Advertisements of Old Time of Shanghai*. Shanghai: Shanghai Huabao Chubanshe, 1995.

Yi, Henry Pu. *The Last Manchu: The Autobiography of Henry Pu Yi, Last Emperor of China*. New York: Simon & Schuster, Inc., 1987.

Yuan, L. Z. *Through the Moongate*. Columns from *Shanghai Evening Post & Mercury*, 1947.

Zhou, Xun, and Gao Chunming. *5000 Years of Chinese Costumes*. Hong Kong: China Books and Periodicals, 1987.

Zhang, Yingjin (ed.), *Cinema and Urban Culture in Shanghai 1922–1943*. Palo Alto, CA: Stanford University Press, 1999.

INDEX

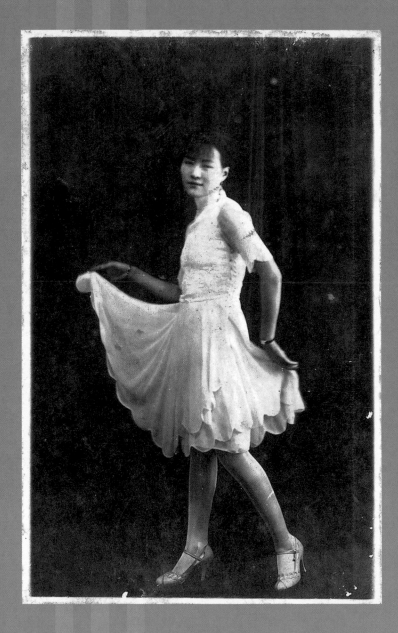

A

Accessories of calendar girls, 73
Actresses. *See also* Wong, Anna
 May; Wu Die
 as calendar girls, 95, 123
 fan mail, 128–129
 fur apparel on, 124, 126
 imitation of clothing, 66
 in Mosquito Journals, 128
 Ruan Lingyu, 120, 122
 from Shanghai film industry,
 96–97
Adrian, 127
Advertising. *See* Calendar girls
All About Shanghai (Lethbridge),
 3
American-Shanghai Telephone
 Company, 17
Amoy, 6
Amusement halls, 38, 41
Architecture of skyscrapers, 21
Art Deco, 21
 Grand theatre, 38
The Art of Knotting (Hsia-sheng
 Chen), 57
Astor House Hotel, 29
 ballroom, 28
Astor theatre, 38
Audacious Angles on China
 (McCormick), 81, 84
Auden, W. H., 9
Automobiles, 14, 15

B

Ballroom dancing, 81
Bank note, 9
Banton, Travis, 134–135
Bathing suits, 67

Beating the Town God, 103
Belle Époque, Paris, 52
Bergman, Ingrid, 140
Berlin, Irving, 80
Bibliography, 143–147
Bicycles, 11
Big Ears Du, 120
Billiards rooms, 32, 33
Black fox furs, 50
Blue clothing, 49
Blue fox fur, 50
Boardman, Eleanor, 107
Bound feet, 46, 48, 56–57
 calendar girl with, 69
 shoes designed for, 59
 Wang Hanlun and, 112, 117
British and American Tobacco
 Company, 117
British Mayfair Mannequin Soci-
 ety, 133
Broadway theatre, 41
Brothels. *See also* Courtesans
 Flower Boats, 98
 Gale, Gracie running, 90, 93,
 95
 lifestyles in, 87
Brown clothing, 49
Buck, Pearl, 136
Bugatti automobiles, 14
Building boom, 21–26
The Bund, 4, 8
 Sassoon, Sir Victor and, 26
Buses, 12, 14
Business cards, 37
Butterfly Wu. *See* Wu Die
Buttons, 57
 on damask silk robe, 63

C

Cabarets, 81
Calendar girls, 52, 68–79
 actresses as, 95, 123
 with bound feet, 69
 cigarette posters, 75, 77
 circa 1915, 71
 circa 1918, 88
 circa 1920, 89
 circa 1925, 72
 circa 1930, 73
 fashions worn by, 73–77
 hand coloring, 72
 in Hong Kong, 73
 photograph of, 91
 Wu Die, resemblance to, 118
Canidrome, 33
Canton, 6
Capitol theatre, 38
Capone, Al, 9
Card rooms, 33
Carriages, 13
Cathay Hotel, 4, 20, 24–26
Cathay theatre, 37
Cercle Sportif Française, 32, 33
Chamber pots, 17
Chan, Amy, 77
Changsam (scholar's robe),
 52–53
Chapei
 film industry and, 104
 theatres in, 41
Chaplin, Charlie, 29
Cheongsam, 53
 in contemporary fashion, 77
 evolution of, 54–56
 foreign residents wearing, 65
 knotted buttons on, 57

New Life Movement on, 67
 Wong, Anna May wearing,
 131, 133
Chew, Ron, 110
Chew, Soo Hong, 110
Chiang Kai-shek, General, 26, 65
 Dai Li, General and, 120
 opium, regulation of, 99
Chiang Kai-shek, Mme., 26
 New Life Movement, 65
 significance of, 67
 Wong, Anna May and, 136,
 140
Children's Palace, 32
China Chic, 69
Chinese City, theatres in, 41
Chinnery, George, 73
Ch'i-ying, Commissioner, 6
Chorus lines, 129
Chou Zhou, 114
Chrysler Building, New York, 38
Cigarettes
 calendar posters, 75, 77
 companies, 72
Cinema. *See* Movies; Theatres
*Cinema and Urban Culture in
 Shanghai 1922-1943*
 (Ou-Fan Lee), 103
Ciro's, 32
Citroen automobiles, 14
Cixi, Empress Dowager, 50
Clothing, 43–67. *See also*
 Cheongsam; Fur apparel;
 Han clothing; Manchu
 clothing; Qi pao
 fur clothing, 50
 New Life Movement and, 65,
 67

Qing dynasty and, 50
 Republic, effect of, 50, 52
 trimmings on, 60
Collars, height of, 50
Collected Acts of the Dynasty,
 48–49
Colonial neoclassical
 architecture, 21
Communication systems, 14, 17
Communists, opium trade and,
 99
Confucianism, 52
 and propriety, 106
Consulates, 11
Cosmetics. *See* Makeup
Courtesans, 81–99
 as calendar girls, 73
 caste system, 87
 circa 1910, 85
 clothing styles and, 52
 lifestyles of, 87
 photographs of, 91
 taxi dancers and, 82, 84
Crawford, Joan, 122, 127
Criminal element, 8–9
The Crimson City, 133
Cultural Revolution, 8, 9
Cushing, Caleb, 6
Customs House
 New Customs House, 4
 Old Customs House, 2

D

Dai Li, General, 120
Damask silk robe, 63
Dangerous to Know, 139
Danish Reading Society, 33
David Sassoon and Sons, 26

Delahaye automobiles, 14
Del Rio, Dolores, 122
Department stores, 36–37
Dietrich, Marlene, 121, 122, 126,
 136
The Difficult Couple, 103
Dior, 77
Dog racing, 33
 courtesans at races, 52
Dove, Billie, 126
Duan zhao (inside-out coat), 50,
 86
Dunne, Irene, 122, 124
Du Yuesheng, 9
 villa of, 10

E

East China Sea, 3
Eastern theatre, 41
"The East is Red," 9
Educated women, movies
 portraying, 105, 112
Edward VII, King, 26
Einstein, Albert, 29
Electric shadows, 103
Emperor, clothing of, 49–50
Extraterritoriality, 7
Eyebrow fashions, 60

F

Face painting, 60
Factor, Max, 115
Factor Studios, 115
Fairbanks, Douglas, 56, 133
Fan Lu, 90
Fan mail, 128–129
Feet. *See* Bound feet; Shoes
Ferry boats, 20

Fingernail polish, 60
 New Life Movement and, 65, 67
Five Blessings at the Threshold, 103
Flower Boats, 98
Flower Smoke Rooms, 98–99
Foochowfoo, 6
Footbinding. *See* Bound feet
Francis, Kay, 66
French Concession, 7
 criminal element in, 8–9
 housing in, 17
 population of, 11
 theatres in, 41
 villa in, 10
Frogs (button closures), 57
From Here to Shanghai (Berlin), 80
Fun in a Chinese Laundry (von Sternberg), 38, 41
Fur apparel, 50
 on actresses, 124, 126
 on opening night, 121

G
Gale, Gracie, 90, 93, 95
Galiano, 77
Gangsters, 8–9
Garbo, Greta, 121, 126
Garden Bridge, 11
Gascoigne Apartments, 24
Geishas, 87
Golden Gate theatre, 38
The Good Earth (Buck), 136
Grand theatre, 38
Grant, Ulysses S., 29
Grauman's Chinese Theater, 132
Great Britain
 Hong Kong to, 6
 Opium Wars, 4–6
 Wong, Anna May in, 140
Great China-Lily Film Company, 120
Great East Gate, 16, 17

Great Northern Telegraph Company, 14, 17
Great World, 41
Green Gang, 9
Greyhound dog racing. *See* Dog racing
Grosvenor House, 22

H
Hairstyles, 60, 65
 of calendar girls, 73
 Wong, Anna May, 134
Han clothing, 46, 48
 modification of conventional jacket and skirt, 70
 Qing dynasty and, 50
 sleeves on, 49
Hand printing, 70
Hanlun Beauty Salon, 117
Hao-Sun, Liu, 53
Har, Wee Gam, 110
Harlow, Jean, 114
Head, Edith, 138–139
Hemlines, evolution of, 56
H.M.S. Duncan, 20, 21
Hollywood publicity still, 107
Hong Kew
 film industry and, 104
 population of, 11
 shoes for customers in, 56
 theatres in, 41
Hong Kong, 6
 calendar posters from, 72–73, 73
 Sassoon, Sir Victor in, 26
Hong Kong and Shanghai Bank, 8
Hooks and eyes, 57
Horse racing, 26, 34–37
 courtesans at races, 52
Hotels, 22–26
Housing, 17
Hoyt, Peggy, 75
Hsia-sheng Chen, 57

Hsu Ling Xu Ling, 120
Huai Hai' Lie district, 19
Huang, Margaret, 69
Huang Jinrong, 9
Huangpu River, 4
 French Concession, 7
Huaniu, 57
 embroidered silk robe, 62
Hudec, Ladislaus, 23, 38

I
India, opium from, 5
Ing, Pearl, 112
Intellectuals, foreign cinema and, 106, 112
International Settlement, 7
 housing in, 17
 Nanjing Road, 37, 40, 41
 population of, 11
 telephones in, 14, 17
 theatres in, 41
Interracial co-mingling in movies, 136
Isherwood, Christopher, 9

J
Jacobi, Lotte, 137, 140, 141
Jazz, 81
Jewelry, calendar girls and, 77
Johnston, Tess, 21
Journey to a War (Auden & Isherwood), 9
Judson, Whitcomb, 57
Junks, 4
Jura Mountains limestone, 70, 72

K
Kadoorie, Elly, 32
Knotted fabric buttons, 57
Kong Sang Hong Ltd., 72
Koo, Mme Wellington, 137
Kuei Gui, 114114
Kwan Kin-Hing, 72–73

Kwan Wai-nung, 72–73

L
Laborer's Love, 103
Lacroix, 77
Lamqua, 72–73
A Last Look: Western Architecture in Old Shanghai (Johnston), 21
Leopard fur, 50
Lethbridge, H. J., 3
Leyser, Lotte and Albert, 38
Lianhau (United) Studio, 104
 Ruan Lingyu and, 120
Libraries, Danish Reading Society, 33
Li chiao, 106
Lilong (housing block), 17
Limestone printing, 70, 72
The Line, 90, 95
Lipsticks, 60
 New Life Movement and, 65, 67
Lithography, limestone for, 70, 72
Little Tokyo, 11
Liu, Edith, 53, 117
Liu Hao-Sun, 116
Liu Song Dynasty, buttons in, 57
Longtang, 17
 in Huai Hai' Lie district, 19
Lotus slippers, appliquéd, 61
Loy, Myrna, 111, 133
Lu Dong Bin, 90
Lumière films, 103
Lyceum theatre, 37
Lynx fur, 50

M
Macao, 6
Magazines. *See also* Mosquito Journals
 movie magazines, 122
Mahjong rooms, 33

Majestic Hotel, 26
 ballroom, 31
 dinner party at, 30
 menu from, 31
Makeup, 60
 of calendar girls, 73
 movies and, 115
Male-female relationships and
 movies, 110–111, 112
Manchu clothing
 in early 20th century, 51
 government employees and,
 48–49
 Han clothing compared, 46,
 48
 horsehoof cuffs, 44, 46
 knotted buttons, 57
 men's robes, 45–46
 Qing dynasty and, 50
 women's robes, 46
Manchu invasion, 1644, 46
Mao Suits, 77
McBain, Captain, 26
McCormick, Elsie, 81, 84–85
Mei Lan-fang, 117, 137
Mei Lin, 102
Metal snaps, 57
Metropole theatre, 37
MGM, 133, 136
Mikawa, 56
Ming dragon robe, 45, 53
 knotted buttons on, 57
Mingxing (Star) studio, 104
 Ruan Lingyu and, 120
Mink fur, 50
Mixed Court, 7
Morris, H. E., 10
Mosquito Journals, 122, 128
 chorus line in, 129
Most favored nations, 7
Motian dalou (magical big build-
 ings that reach the skies), 21
Movies, 103–129. See also
 Actresses; Theatres

educated women, portrayal of,
 105, 112
fan mail, 128–129
golden age of film industry,
 105
industry in Shanghai, 104–105
intellectuals embracing, 106,
 112
makeup for, 115
male-female relationships and,
 110–111, 112
opening nights, women at, 121
set on working film studio,
 104
star promotion and competi-
 tion, 122
Muni, Paul, 136
Municipal Council, 7–8

N
Nanjing Road, 37, 40, 41
Nanking, Treaty of, 4, 6
Nationalist government, 65
Native City. See Old City
Nazimova, Alla, 133
New Life Movement, 65, 67
 Wong, Anna May and, 136
Nightclubs
 Ciro's, 32
 supper clubs, 81
Night soil collector, 17
Ningpo, 6
North China Daily News, 10
Northern Ocean Channel, 4
Nursing mothers, clothing for,
 49

O
Odeon theatre, 38
Old City
 entrance to, 16, 17
 Flower Smoke Rooms in,
 98–99
 modernization in, 17

Olivier, Laurence, 133
Opium, 5
 Communists and, 99
 Du Yuesheng and, 9
 Flower Smoke Rooms, 98–99
 prostitutes and, 98–99
 smokers of, 99
Opium Wars, 4–6
Orange clothing, 49
Ou-Fan Lee, Leo, 103

P
Pajamas, 113
Palace Hotel, 22
Paris theatre, 38
Parker and Turner, 26
Park Hotel, 22–24
Patrick, Gail, 125
Peace Hotel, 4
Peng, Eugene, 117
Permanent wave machines, 65
Personal hygiene, 65
Peugeot automobiles, 14
Pheasants (streetwalkers), 95
Photographs. See also Publicity
 stills
 of calendar girls, 91
 of courtesans, 90
Pickford, Mary, 56
Portugal, 6
Powell, William, 111
Prada, 77
Prostitutes. See also Courtesans
 calling cads of, 90
 Communists and, 99
 yao er, 87, 90
Publicity stills, 106
 Hollywood publicity still, 107
Pu fu, 50

Q
Qianlong, Emperor, 48–49
Qing dynasty, 4, 50
 knotted buttons in, 57

opium use and, 99
opportunities for women in,
 106
Qi pao, 53
 buttons on, 57
 Chiang Kai-shek, Mme. wear-
 ing, 67
 classic rayon qi pao, 79
 as favored garment, 77
 from late 1920s, 58
 pajamas, 113
 silk chiffon qi pao with white
 fox stole, 76
 silk gauze qi pao, 64
 sleeves on, 60, 65
 ultra-chic, circa 1930s, 94
 with white fox stole, 119
 for working girls, 92
Queer Clothing stamp, 65, 67

R
R. A. Curry, 23
Rabbit fur and silk embroidered
 jacket, 74
Radio City Music Hall, New
 York, 38
Rainer, Luise, 136
Red balsam blossom juice, 60
Red clothing, 49
The Red Lantern, 133
Renault automobiles, 14
Republic, opportunities for
 women in, 106
Rickshaws, 11, 13
 on longtang, 17
Ritz theatre, 38
Rockefeller Center, New York,
 38
Romantic relationships, movies
 portraying, 110–111, 112
Roosevelt, Eleanor, 67
Rouge, 65, 67
Roxy theatre, 38
Ruan Lingyu, 120, 122

Ruling from the Dragon Throne (Vollmer), 45
Russell, Rosalind, 127
Russian Ball, 26
Russians. *See* White Russians

S
Sable furs, 50
St. Mary's College, Shanghai, 117
Saint Laurent, 77
Salmson automobiles, 14
Sampans, 2
 in Suzhou Creek, 5
Sampson ferry boat, 20, 21
Sassoon, Albert, 26
Sassoon, David, 26
Sassoon, Sir Victor, 22, 24–26
Sedan chairs, 11, 13
Seeking Happiness Lane, 90
Senefelder, Alois, 70
Seward Roads, 13
Shanghai Club, 33
 Cercle Sportif Française, 32, 33
Shanghai Express, 133, 136
Shanghai Film Company, 112
Shanghai Museum, 8
Shanghai Pudong Development Bank, 8
Shanghai Race Club, 34–35
Shanghai Who's Who 1933, 9
Shaw, Ralph, 9
Shearer, Norma, 122, 127
Shikumen districts, 17
 architecture of, 18
Shoes, 56
 gold leather embroidered silk pumps, 109
 lotus slippers, appliquéd, 61
 open-toed black suede silk embroidered shoes, 108
 pigskin shoe, 59
 publicity still with, 107
 silk damask pump, 59
Sikh policemen, vii, 14

Silent films, 103
 by Wang Hanlun, 117
Silk gauze qi pao, 64
Silver Star (Yinxing), 122
Sincere Company, 37, 39
Sin City (Shaw), 9
Sing-song girls, 84–87
Skirts, shortening of, 56
Skyscrapers, 21
Sky Terrace, Park Hotel, 22, 24
Sleeves
 evolution of, 55–56
 New Life Movement on, 67
 on qi pao, 60, 65
Snaps, 57
Social clubs, 33
Solnhofen limestone, 70
Song dynasty, 4
Sporting clubs, 33
Sporting events, courtesans at, 52
Star theatre, 38
Streetcars, 13
Streetwalkers, 95
Summer robes, 64
Sun Company, 37
Sun Sun, 37
Supper clubs, 81
Suzhou Creek, 3, 5, 7
Swimming pools, 33

T
Taiwan, Chiang Kai-shek in, 65
Talbot automobiles, 14
Talking pictures, 103
Talmadge, Constance, 75
Talmadge, Norma, 75
Tam, Vivienne, 69, 77
Tang, Shanghai, 77
Tang dynasty, 3
Tan Zinpaei, 103
Taohuawu art studio, 70
Taoist faith, 90
Taxi dancers, 82, 84
Telephone system, 14, 17

at Astor House, 29
Temple, Shirley, 122
Theatres, 37–38, 41
 ticket prices, 41
The Thief of Baghdad, 133
The Thin Man, 111
Tianyi (Unique) studio, 104
Tiger Bay, 133
The Toll of the Sea, 133
Tram system, 13, 14
Transportation, 11–14
Treaty of Nanking, 4, 6
Treaty of Wanghsia, 6–7
Trimmings on clothing, 60
Tulchan Lodge, Speyside, 26
Turf Personalities, 1928, 26
Turkey, opium from, 5
Tyler, John, 6

V
Valentino, 77
Veysseyre, Paul, 33
Victoria, Queen, 26
Villas
 for foreigners, 22
 in French Concession, 10
Vollmer, John, 45
Von Sternberg, Josef, 38, 41, 133, 136

W
Waldorf Astoria Hotel, New York, 38
Wang Hanlun, 112, 117
Wanghsia, Treaty of, 6–7
Warring States Period, 57
Wayside theatre, 41
Wellesley College, 65
Wesleyan College, 65
Wheelbarrows, 11, 13
 on longtang, 17
White rice powder, 60
White Russians, viii
 description of, 83
 extraterritoriality and, 7

at Majestic Hotel, 26
Willow pencils, 60
Wing On, 36, 37
The Women, 127
Women Daily (Gunu Ribao), 122
Wong, Anna May, 130–142
 in Britain, 140
 in China, 136–137
 in Edith Head gowns, 138–139
 in Europe, 133
 hairstyle of, 134
 Jacobi, Lotte, photographs by, 137, 140, 141
Wong Liu Tsong. *See* Wong, Anna May
Working girls, 81–99. *See also* Actresses; Courtesans
 sing-song girls, 84–87
 taxi dancers, 82, 84
Wu Die, 117–129, 122
 Wong, Anna May and, 137
Wusong River, 3

X
Xiao boa, 122
Xintiandi District, 18

Y
Yangtze River, 3
Yan Ruisheng, 103
Yao er, 87, 90
Yellow clothing, 49
Yihua (China Artist) studio, 104
Yin Mingzhu, 112
Yipinxiang Hotel, 81
Young, Loretta, 140
The Young Companion, 122
Yuan, 41
Yuan dynasty, 4
Yuefenpai. See Calendar girls

Z
Zhang Schichuan, 103
Zippers, 57, 60